IMAGES
of America

WESTFORD

IMAGES
of America

WESTFORD

The Westford League of Women Voters

League Members
Ellen Harde, Text
Beth Shaw, Photo & Caption Editor

ARCADIA
PUBLISHING

Copyright © 1996 by the Westford League of Women Voters
ISBN 978-0-7385-5657-4

Published by Arcadia Publishing
Charleston, South Carolina

Printed in the United States of America

Library of Congress Catalog Card Number: 2007942119

For all general information contact Arcadia Publishing at:
Telephone 843-853-2070
Fax 843-853-0044
E-mail sales@arcadiapublishing.com
For customer service and orders:
Toll-Free 1-888-313-2665

Visit us on the Internet at www.arcadiapublishing.com

Contents

Acknowledgments

Thanks to those people of Westford who have been a part of making this book, beginning with the many members of the League of Women Voters noted on p. 121 who spent two years interviewing many longtime residents for the 1979 slide-tape version of "Westford: A Sense of Community." The wonderful memories of those we interviewed, listed on p. 122, were incorporated into the narrative.

Avis Hooper narrated the slide-tape production, along with Allister MacDougall who read the newspaper account of the 1938 hurricane, and Ellen Rainville who sang "Simple Gifts" as the theme music for the tape.

Westford historians and friends listed on p. 126 shared their archival photographs with us, and Jim Lacey helped us pull the slide-tape show together as our technical advisor and producer.

For this book, Jan Timberlake was the link between the League and Arcadia Publishing; Westford historian June Kennedy once again graciously shared her knowledge with us; Reference Librarian Tom Brennan allowed us unlimited access to the Fletcher Library archives; Curator Maureen Raia let us pore through Westford Museum files; and League members Lynn Cohen and Lisa Garvey provided production assistance.

Introduction

As the Town of Westford readied to celebrate its 250th anniversary in 1979, issues of growth and land use were dividing the townspeople. Plans to change zoning were seen by many longtime residents and large landowners as restrictions that would take away their right to sell or develop their land.

In the role of consensus builder, the Westford League of Women Voters decided to look back at the town's past to see if there were lessons to be learned from our history that would help the town deal with its current differences.

The result: a thirty-minute slide-tape show entitled "Westford: A Sense of Community." After two years of taping remarkable conversations with local and native senior citizens, locating treasured old photographs from a variety of sources, taking new pictures, and then writing a script, the League premiered their labor of love in February 1979.

The text and photographs from the slide-tape show form the basis for this new book.

Not surprisingly, the issues of growth and land use continue to be among the town's primary concerns. By area Westford is the second largest town in Middlesex County, covering 30 square miles. Population trends reveal Westford's phenomenal growth over the last century. In 1875 there were 1,933 people in Westford; eighty years later in 1955 the population was 4,923. Census figures for the past thirty years are even more dramatic, with the population soaring to 8,283 in 1965, 12,965 in 1975, and 18,186 in 1996. As we begin a new century with continued growth, the message of *Westford* remains relevant.

The lands that today constitute Westford were originally inhabited by the Pawtucket, Nashoba, and Wamesit Indian tribes. The Native Americans were undoubtedly attracted by the seven freshwater ponds and the natural wealth of berries and fruits found here. The first known white man to settle in Westford was Solomon Keyes, who arrived in 1664 from Newbury, Massachusetts, with his wife, Frances Grant. At that time Westford was part of Chelmsford, which had been incorporated in 1655. By 1729 Westford had separated from Chelmsford. In 1730 a small triangular piece of land in Groton was annexed to Westford, and the boundaries have remained the same ever since.

Politically, Westford is far more diverse today than when it was founded. Early political and religious life in Westford reflected the laws of this state, and from the early years of the Commonwealth until the 1830s, a legal relationship existed between Town and Parish. Towns in Massachusetts were not allowed to become incorporated until they had constructed a meetinghouse (church), supplied a minister, and provided a parsonage.

Each town resident was then taxed, in order to support church and pastor, and church attendance was compulsory. Westford's third meetinghouse, built in 1794, exists today as the

First Parish Church. It wasn't until the 1830s that the legislature granted residents the privilege of belonging or not belonging to the religious society of their choice.

In 1920, twenty million American women won the right to vote and the national League of Women Voters was established that same year. In 1974, men were granted full and complete membership in the League, rather than their former associate (non-voting) membership. Associate memberships remain open to non-citizens.

The League of Women Voters of Westford was formed in 1967. The League does not support or oppose any political party or candidate. Locally and nationally the League is a nonpartisan political organization which encourages the informed and active participation of citizens in government and works to influence public policy through education and advocacy. The eighty-five women and men of the Westford League of Women Voters are pleased to present *Westford*.

Ellen Harde
Beth Shaw
March 5, 1996

One

A Fascinating and Diverse Mixture

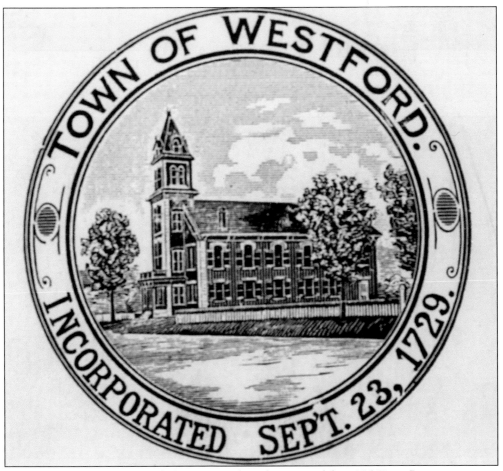

The Westford town seal, which first appeared on the cover of the 1895 Town Report.

Westford Massachusetts. A town of 18,000 people, living throughout 30 square miles and appearing at first glance to be an upper-middle-class bedroom suburb. Top photograph: Grassy Pond on Plain Road across from Villanova Drive. Bottom photograph: Alice Brosius and Sheryl Sullivan working at Drew Farms on Boston Road, 1977.

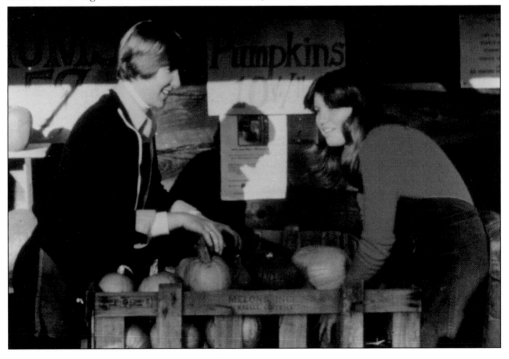

Top photograph: Looking northwest from the bell tower of the First Parish Church, Main Street. (Seavey photograph.)

Bottom photograph: 9 Sassafras Road off Vose Road.

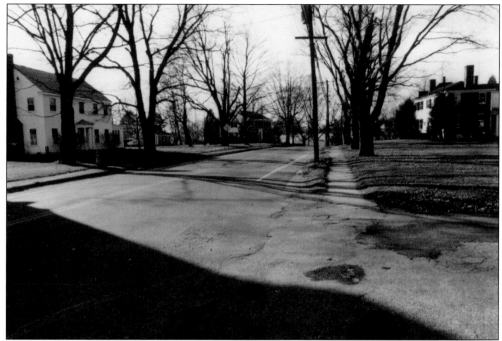

In fact Westford is a fascinating and diverse mixture of many backgrounds; of old and new, of rural and suburban, of proponents for change and preservers of the status quo. Top photograph: Looking west on Pleasant Street at the intersection of Pine Street. Bottom photograph: Bradford Street, Forge Village.

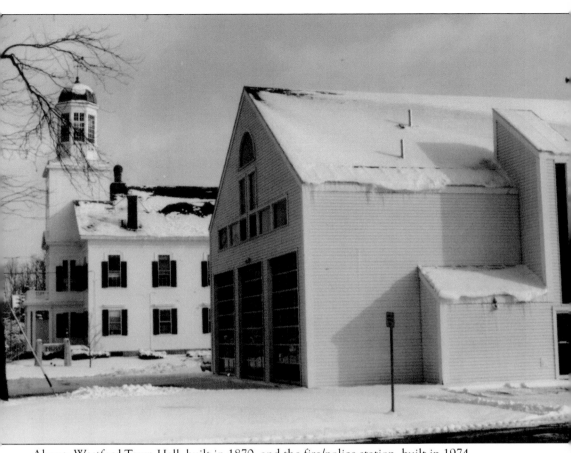

Above: Westford Town Hall, built in 1870, and the fire/police station, built in 1974.

Top photograph: Stone wall on Vose Road. (Lacey photograph.)

Bottom photograph: 11 Newport Drive, Nabnasset.

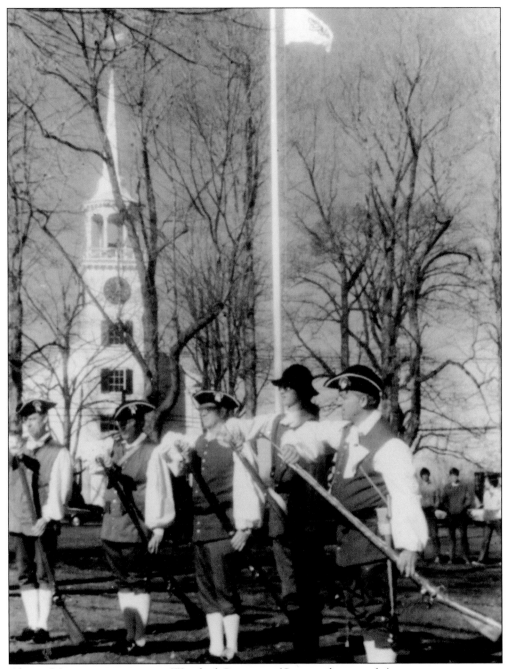

Above: Minutemen muster on Westford Common. (Seavey photograph.)

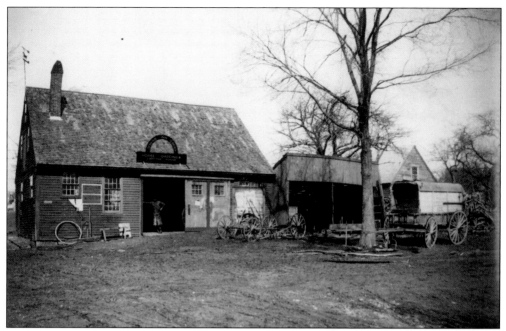

There is an important common link, however, among all of Westford's buildings, lands, and people, and that link is the town's past. Top photograph: Blacksmith at the intersection of Chamberlin Road and Main Street. (Day photograph.) Bottom photograph: Broadway in Graniteville, next to today's Parent's Market.

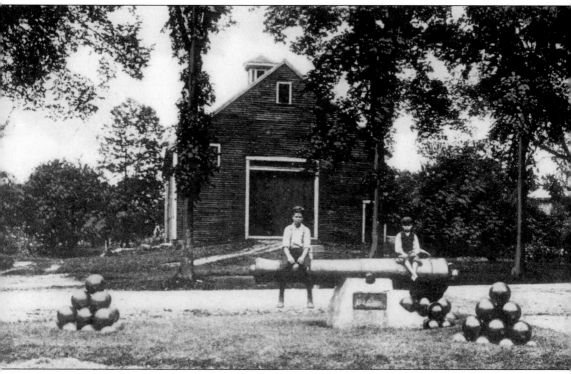

The last ninety years in Westford have shaped the Westford of today. By better understanding those years, we can reach a better understanding of each other. Above: Cannon on Westford Common with the Osgood barn in background. The barn was razed in January 1971 to make room for the fire/police station. (Kennedy collection.)

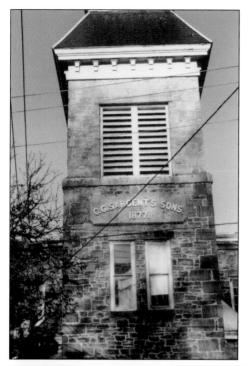

A significant change occurred in Westford at the turn of this century that had a great impact on the town. Up through 1900, town records indicate that marriages were between well-established local families. The brides and grooms were Sargents, Prescotts, and Spaldings; they were Fletchers, Wrights, and Whitneys. Top photograph: C.G. Sargent's tower, Broadway near North Main Street, Graniteville. Bottom photograph: The Prescott headstone in West Cemetery, Country Road at Route 225. Arnold Wilder is on the right.

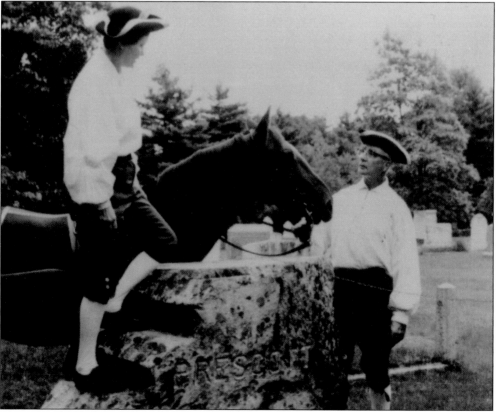

GROWING MORE WOOD
for a GROWING NATION

WESTFORD
TOWN FOREST

This 13 Acre Tract is Part Of
122 Acres Of Forestland, Given in
1935 To The Townspeople By
OSCAR R. SPALDING

Top photograph: Town Forest, Cold Spring Road at Forge Village Road. The sign was erected in 1958 by Gordon Seavey. (Seavey photograph.)

Bottom photograph: J.V. Fletcher Library, Main Street.

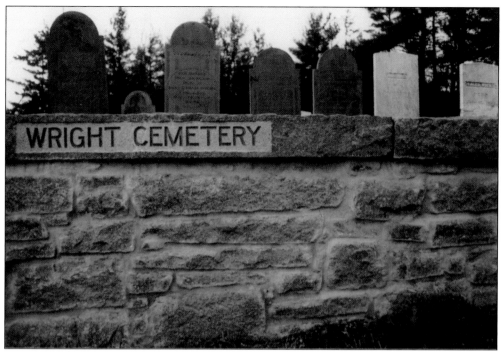

Top Photograph: Wright Cemetery, Groton Road (Route 40) across from Lynwood Lane.

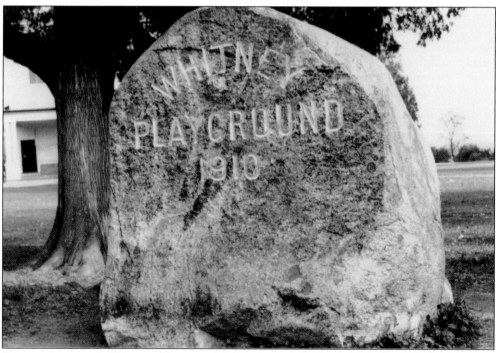

Bottom photograph: Whitney Playground, Main Street between Frost and Roudenbush.

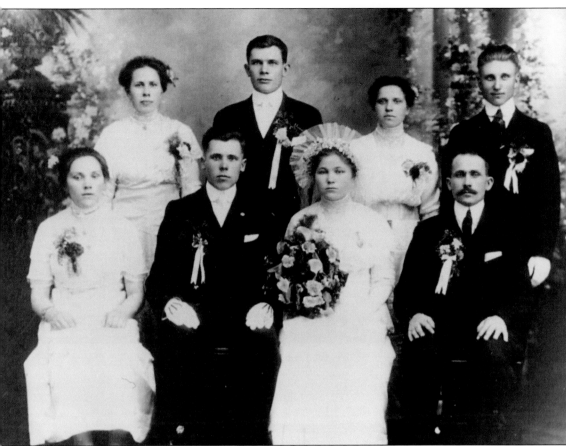

But by 1910, the town report shows a new a very different trend. Only fifteen of the fifty newlyweds that year had been born in this country, much less the town. Fifteen had been born in Russia, ten were of French-Canadian birth, and the other nine young marrieds were born in Germany, Italy, England, and Australia. Above: The May 18, 1918, wedding of Wasil Belida and Alexandra Sechovich. From left to right are: (front row) Feredora Sechovich, the groom, the bride, and Mr. Britko; (back row) Mrs. Britko, Viachaslaw Britko, Julia (Tarasevich) Harasko, and Anthony Tarasevich. (Kennedy collection.)

It was not the farmland and it was not the apple orchards that brought these people to Westford. They came to work in the mills and factories powered by the waters of Stony Brook in Forge Village and Graniteville. Top photograph: Nashoba Valley Ski Area on Nashoba Hill as seen from Route 225 south of Route 110. Bottom photograph: Drew Farms orchard, east side of Boston Road, north of Route 495.

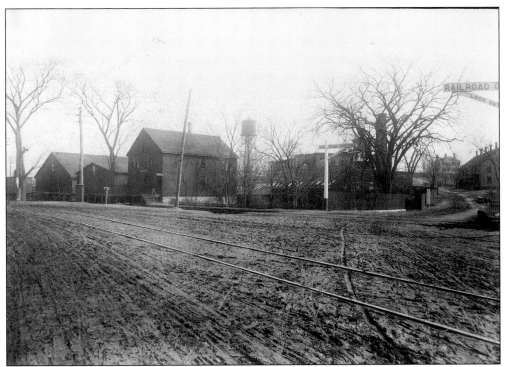

Top Photograph: Abbot Worsted from West Prescott Street, looking east to East Prescott and Pleasant Streets, 1905. (Frank Penney photographer, Fletcher Library collection.)

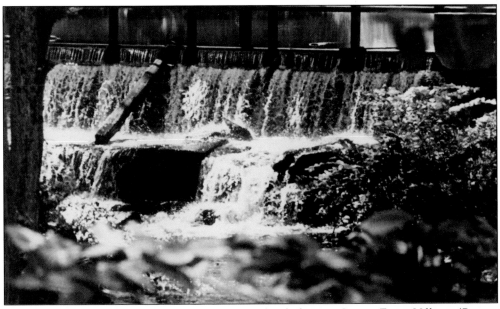

Bottom photograph: The Stony Brook dam south of Pleasant Street, Forge Village. (Pigeon photograph, Kennedy collection.)

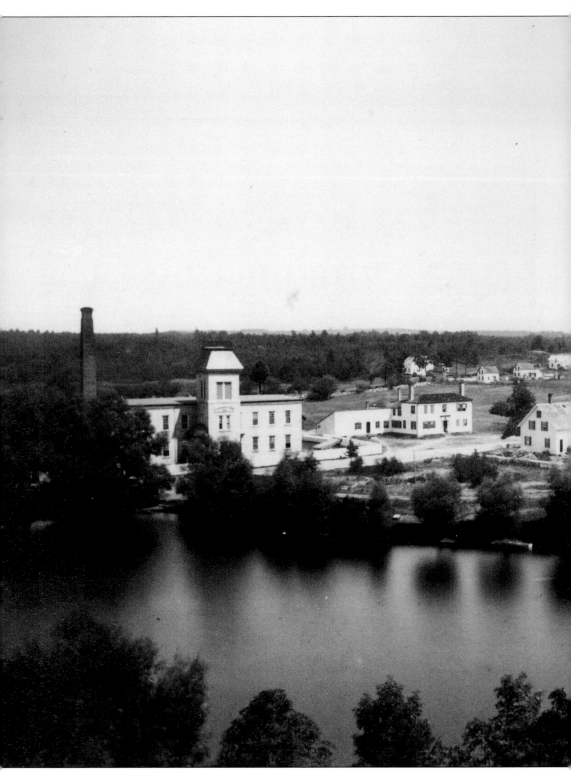

Above: Graniteville in 1882 with C.G. Sargent's tower, Broadway, at left and the Methodist

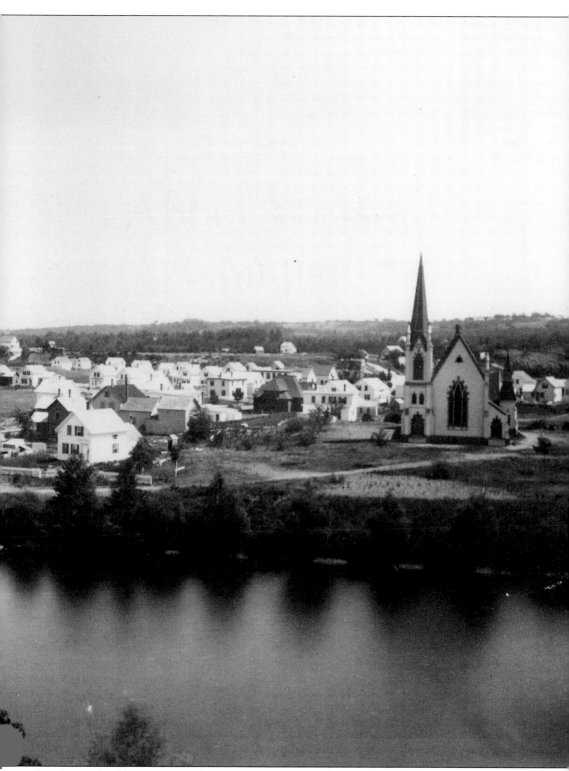

church at right. (A.C. Sargent photograph, Kennedy collection.)

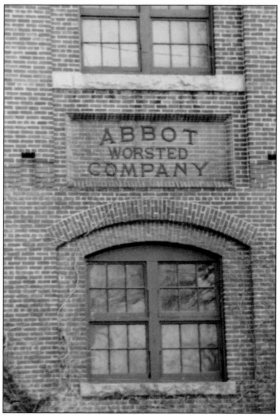

Many immigrants were employed manufacturing C.G. Sargent's machinery, which was sold worldwide to the flourishing textile industry. But the majority of workers came from Europe and Canada to work at the Abbot Worsted Company. Top photograph: The mill pond and C.G. Sargent's buildings on Broadway in Graniteville from North Main Street. Bottom photograph: The west wall of the Abbot Worsted mill, Pleasant Street, Forge Village.

Two

Abbot Worsted Company

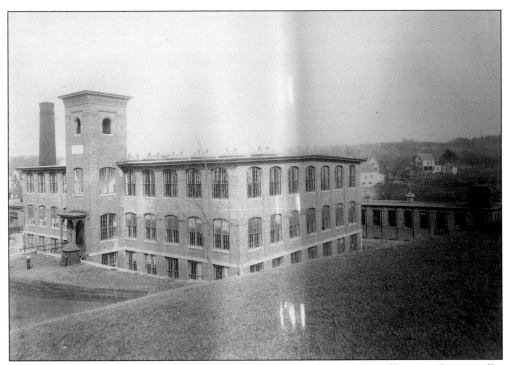

Abbot Worsted Company had mills alongside Stony Brook in Forge Village, in Graniteville, and at Brookside, which is now Nabnasset. Above: The south facade of the Abbot Worsted mill, Pleasant Street, Forge Village in 1905. (Penney photograph, Fletcher Library collection.)

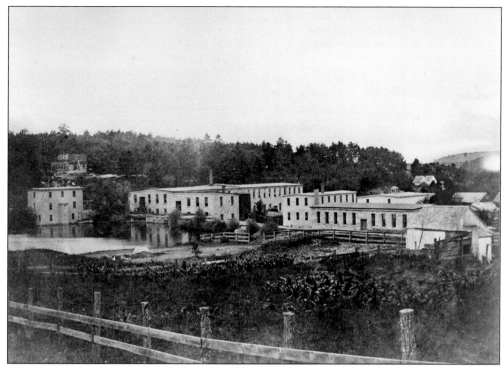

Top photograph: Graniteville from the site of the Methodist church. (Fletcher Library collection.)

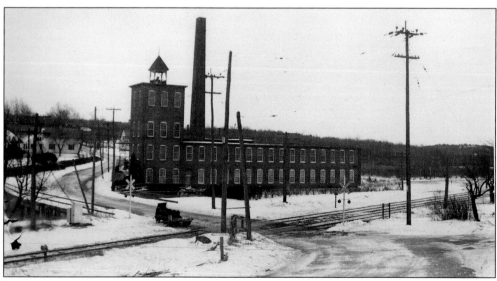

Bottom photograph: Brookside mill, on the west side of Brookside Road. (Fletcher Library collection.)

Says Westford native Alex Belida: "They had recruiting agents go down through the Russian villages in those days and entice them to come, because of course labor was very short in America in those days. So they packed their bags, whatever they had, the clothes on their backs and they came, that's all. Top photograph: A corner of the Abbot mill office, 1905. (Penney photograph.) Bottom photograph: Reeling and packing room, Abbot Graniteville mill. (Penney photograph.)

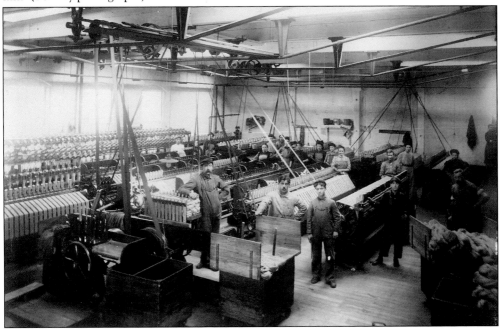

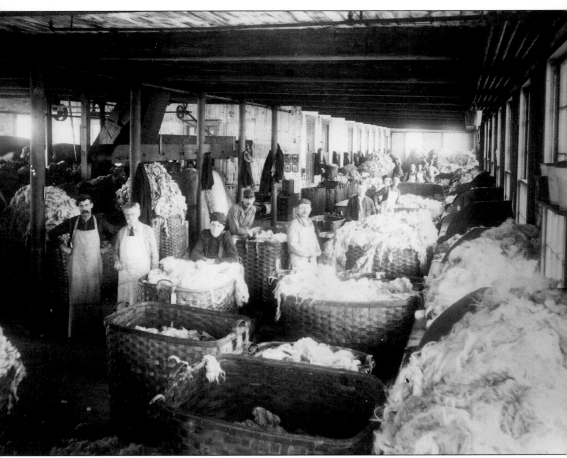

Mr. Belida continues: "They came in cattle boats and everything else, and that's how they came here. First of all they came at a young age, anywhere from twelve to fifteen, and they came alone. The object, most of them, was to make a few dollars, to make a killing and go back, you see. But I think World War I interfered with that and they stayed, 'cause you couldn't go back—and that's how most of us stayed here." Above: Wool sorting room. From left to right are: William Welsh (overseer), Henry Smith (superintendent), and George McCarthy. (Penney photograph.)

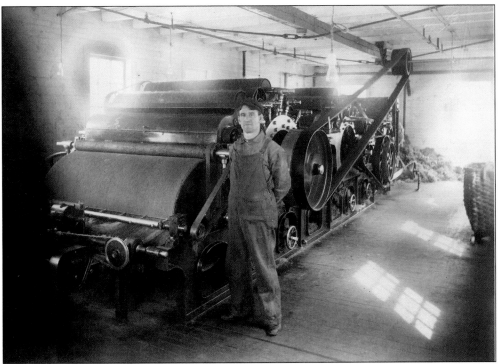

Top Photograph: James Payne in the carding room. (Penney photograph.)

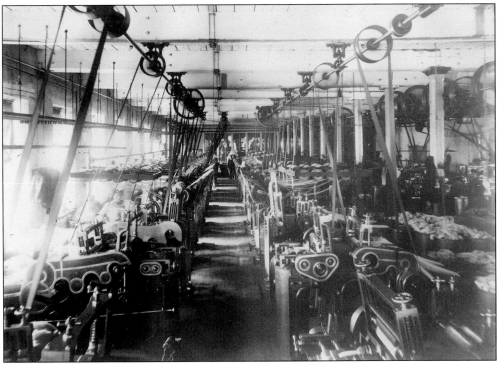

Bottom photograph: Worsted drawing room. (Penney photograph.)

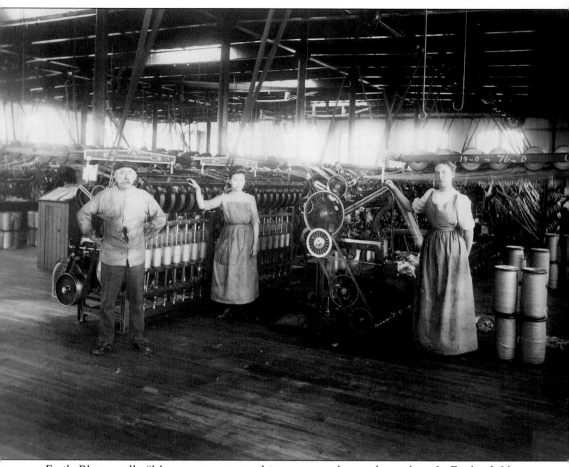

Emily Blott recalls: "My parents came to this country to better themselves. In England, I began working in the mill when I was twelve. Here, I was fifteen. I worked six days a week and the pay was four dollars and eighty cents." Above: Worsted drawing room. (Penney photograph.)

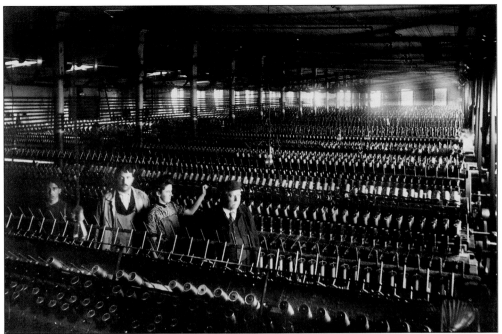

Jacob Tereshko remembers: "I get lucky. I get eight dollars ten cents for fifty-four hours. That good, that good, that good pay." Top photograph: Alvin Nelson is second from the left and Henry Smith (superintendent) is at the far right in this scene from 1905. (Penney photograph.) Bottom photograph: Alvin Nelson and Henry Smith in the reeling and packing room (also 1905). (Penney photograph.)

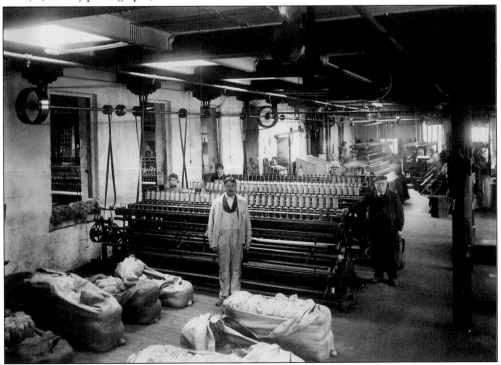

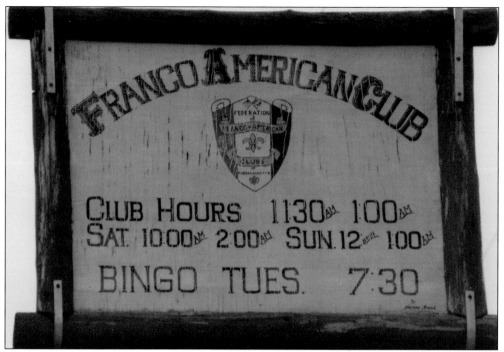

The different nationalities preserved their own traditions. Top photograph: The Franco-American Club sign, West Prescott Street, near the Groton town line. Bottom photograph: Sedach headstone in the Russian Brotherhood Cemetery on the north side of Patten Road between Route 225 (Pleasant Street) and Country Road.

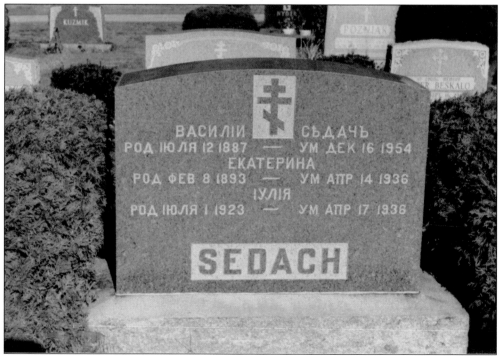

Recalls Alex Belida: "Most of the Russians came in the early 1900s, anywhere from 1900 to 1910, and none of them, none of the women and very few men, got citizenship papers even though they decided to stay. Later they organized a cemetery, the Russian Brotherhood Cemetery." Top photograph: The entrance to the Russian Brotherhood Cemetery. Bottom photograph: The Russian Brotherhood Cemetery. (Westford Academy collection.)

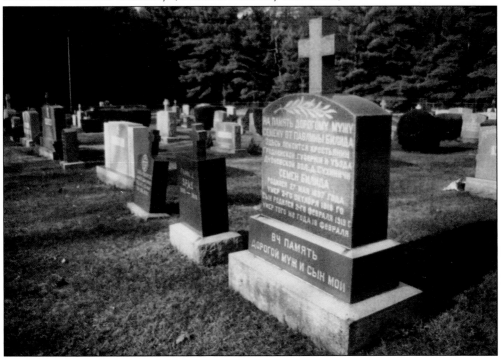

And the immigrants kept their own languages. War registration notices in 1917 were posted in the mills in Polish and Russian as well as English. Abbot Worsted provided interpreters in four different languages: Russian, Italian, Polish, and French. Above: Polish language World War I war registration notice.

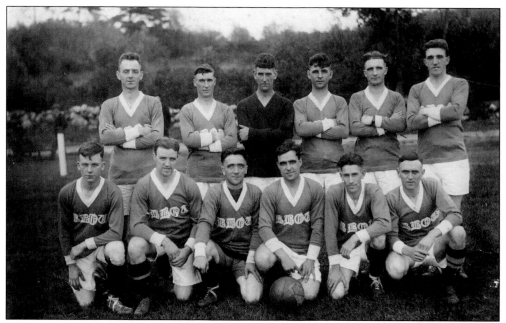

Abbot not only provided employment, but met the worker's every need. The ball fields in Forge Village and Graniteville—now owned by the town—were originally built and maintained by the company for their own soccer and baseball teams. John C. Abbot traveled personally to Keithley, England, to recruit the best soccer players to work in his mills. Top photograph: Abbot Worsted soccer team. From left to right are: (back row) Tom Cosgrove, Archie Duncan, Jock Davidson, Bill Kelly, Jack Corrigan, and Billie Ross; (front row) Jimmy Farguar, David O'Neil, Larry Kane, Jack Kershaw, Jack Dundas, and Dave Quinn. (Fletcher Library collection.) Bottom photograph: Abbot Worsted baseball team. (Westford Museum collection.)

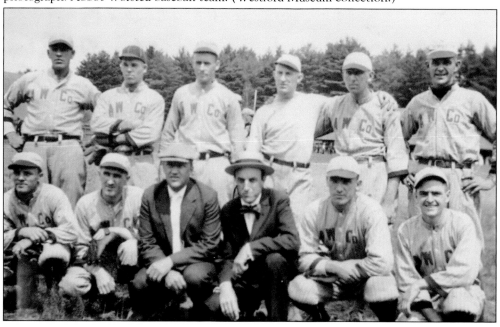

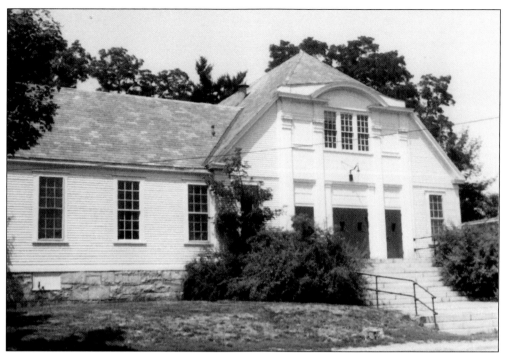

Abbot Hall provided dancing and movies, and Abbot Clubhouse—now used by the Elks—had bowling alleys, horseshoe pits, and a lighted ice rink, which was home ice for the Forge Village Arrows. Top photograph: Abbot Hall on the west side of Bradford Street, south of Pleasant Street, torn down March 12, 1980. (Seavey photograph.) Bottom photograph: Littleton-Westford Elks Lodge on Coolidge Street in Forge Village.

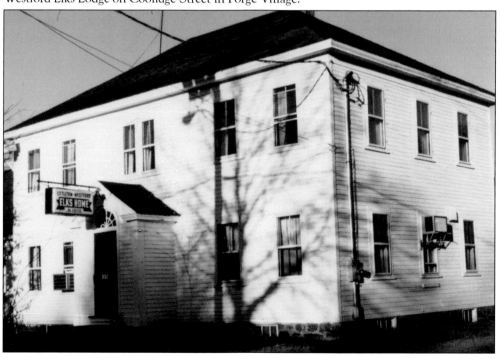

Above: Horseshoe pits on Coolidge Street in Forge Village.

Across Pleasant Street from the mill, the hospital and its complete staff provided medical and dental care. Top photograph: Forge Village Arrows. Bottom photograph: Prescott House, 10 Pleasant Street, built *c.* 1760. (Fletcher Library collection.)

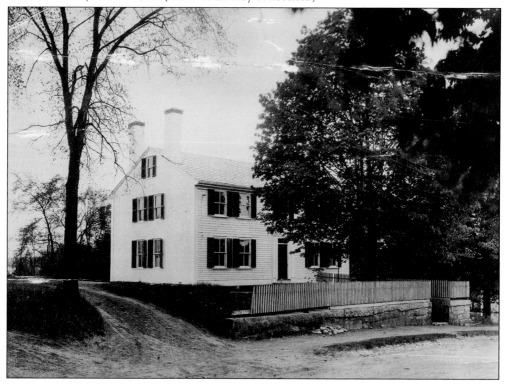

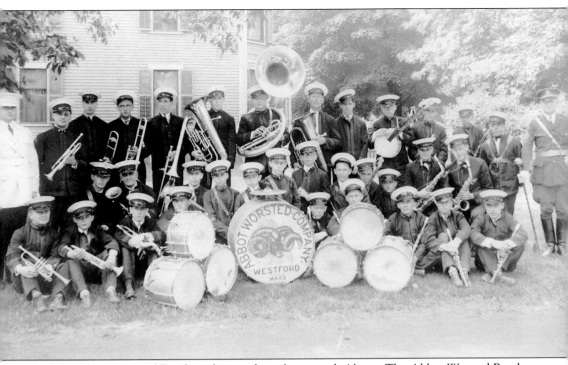

And the Abbot Worsted Band was known for miles around. Above: The Abbot Worsted Band. (Kennedy collection.)

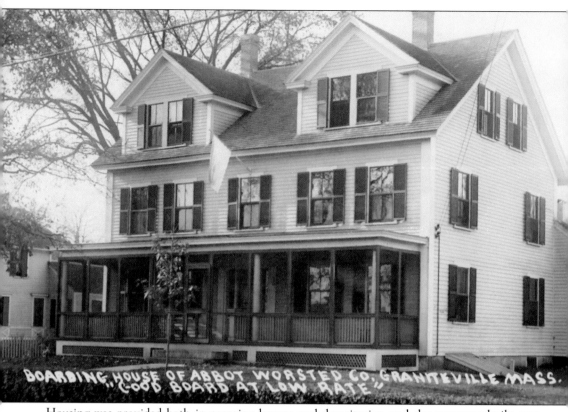

Housing was provided both in rooming houses and dormitories, and the company built over five hundred units of duplex and single-family homes that were rented to the workers. Above: Abbot boarding house, 66 Broadway, Graniteville. (Kennedy collection.)

Says Mrs. Edward Abbot: "The Abbot Worsted took care of its help very well. They built houses for them and so forth and so on." Top photograph: 19–21 Bradford Street, Forge Village. Bottom photograph: 10 Pine Street, Forge Village.

By 1936, one half of Westford's population of 3,700 was employed by the Abbot Worsted Company. Top photograph: MacQuarrie home, 23 Abbot Street, Forge Village. Bottom photograph: Pond Street looking north to Pleasant Street, Forge Village.

Three

Other Local Industries

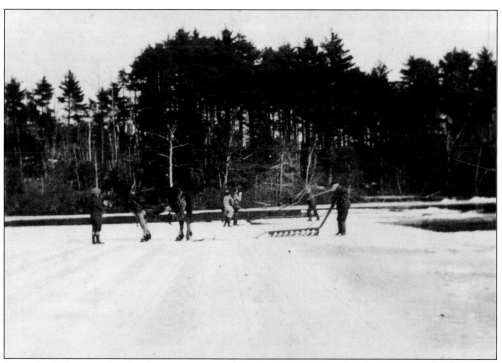

Though Abbot was by far the primary employer in town, other local industries also bolstered the economy and provided jobs within the town for residents. In the winter, there was ice cutting on the pond. Above: Ice cutting on Forge Pond. (Kennedy collection.)

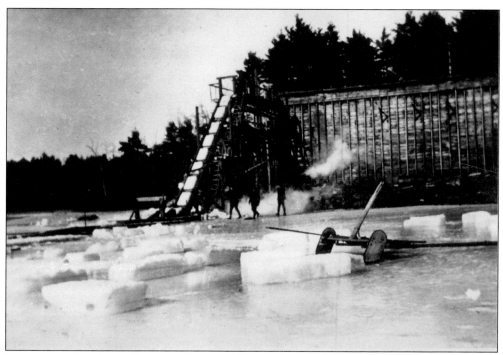

Ice was stored in the ice houses at Forge and Burge's Ponds. Top photograph: The ice house on Forge Pond. (Kennedy collection.) Bottom photograph: Loggers use horses to drag logs through the woods to the sawmill. (Day photograph.)

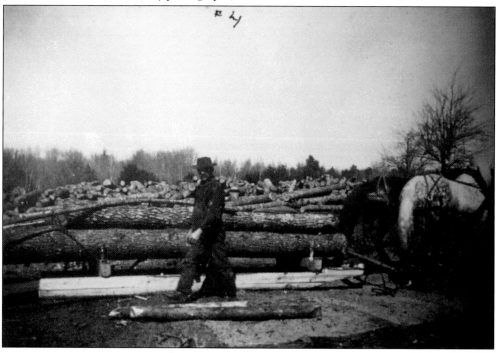

At the sawmill at the Stony Brook depot logs were milled and the lumber shipped off by train. Above: Looking north to the sawmill on Depot Street at Stony Brook. The present-day Burbeck Way may be seen at the right. (Day photograph.)

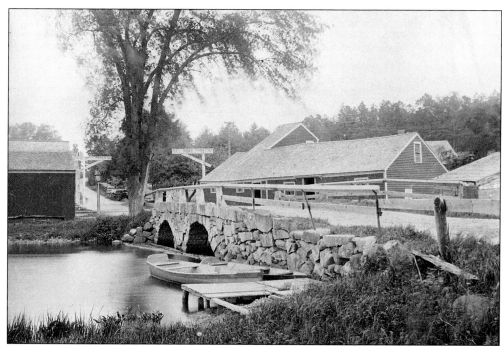

There were half a dozen quarries in the town, and one off Groton Road provided the four original pillars for the Quincy Market building in Boston in 1826. Top photograph: Depot sawmill from the southwest side of Depot Street. (H.H. Robinson photograph, Fletcher Library collection.) Bottom photograph: H.E. Fletcher and Company quarry, Groton Road at the Chelmsford line. (Kennedy collection.)

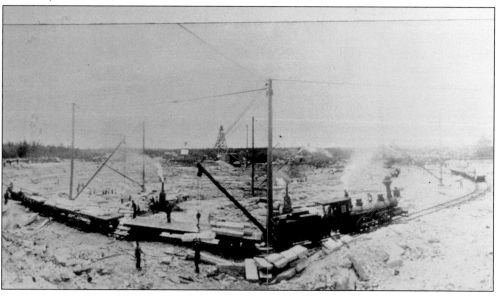

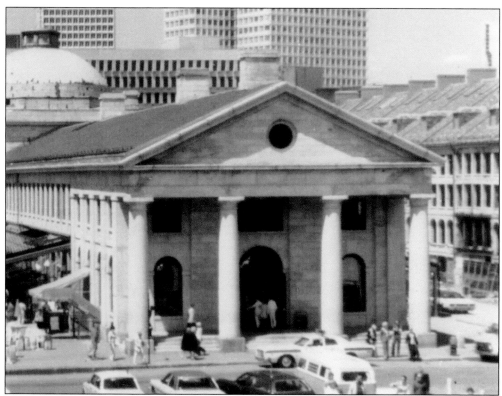

And Westford produced apples. In the 1930s, the Nashoba Fruit Belt reached from Westford to Worcester and produced two-thirds of the state's apples in one-twentieth of its area. Top photograph: Faneuil Hall, Boston. (Dexter photograph.) Bottom photograph: Mary Lacey enjoys apple blossoms in the Drew orchards on Boston Road. (Lacey photograph.)

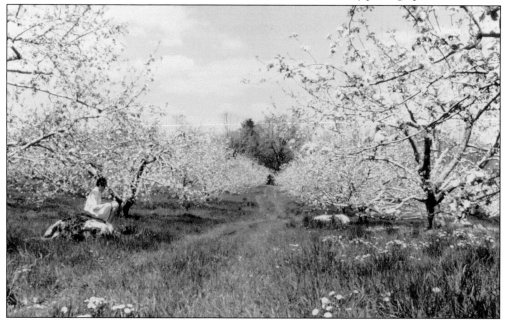

Apple growers throughout the Nashoba Valley celebrated their success by holding an annual Apple Blossom Festival. Top photograph: Carl Anderson at Anderson's cold shed, on the north side of Chamberlin Road near Main Street. Bottom photograph: Governor Curley with the 1935 Apple Blossom Queen.

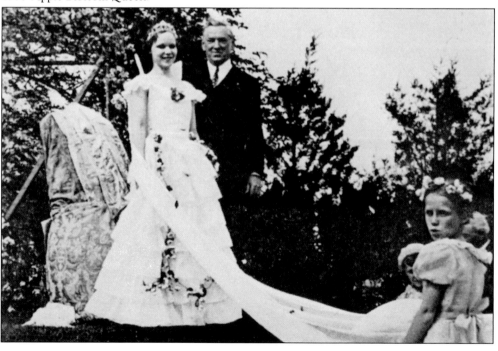

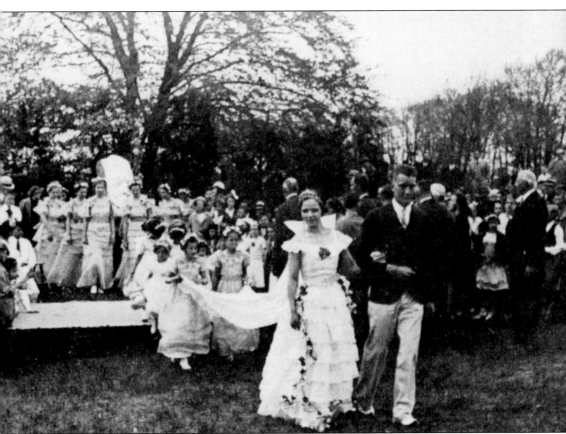

In 1935 and '36, His Excellency James Michael Curley, Governor of Massachusetts, crowned the Apple Blossom Queen as part of a two-day festival. The extravaganza concluded with a ball at the town hall and dancing to the music of Jack Marshard's orchestra. Above: Ben Drew escorts the 1935 Apple Blossom Queen, Phyllis Wright.

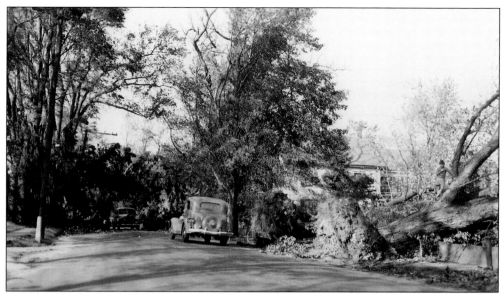

Two years later, the apple industry suffered a devastating blow. On September 21, 1938, the town was hit by the Great Hurricane, and 50 percent of the apple crop was destroyed. The town was brought to a standstill. Top photograph: Boston Road, looking north to the Common. (Mabel Prescott photograph.) Bottom photograph: The Common looking south to Lincoln Street from Fletcher Library. (Prescott photograph.)

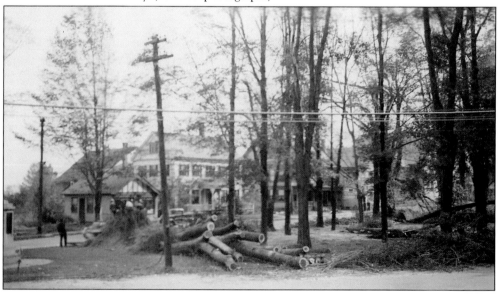

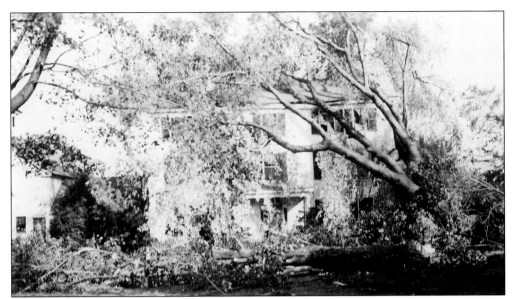

The *Lowell Courier Citizen* reported: "Hundreds of lovely elms, maples and pines are flat, the town completely cut off from the outside world, no electricity, only a few telephone lines in service." Top photograph: 24 Main Street, then the Marian Winnek house. (Prescott photograph.) Bottom photograph: Westford Common as seen from Boston Road, with the First Parish Church at the far right. (Prescott photograph.)

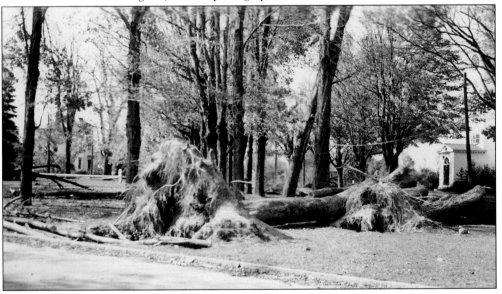

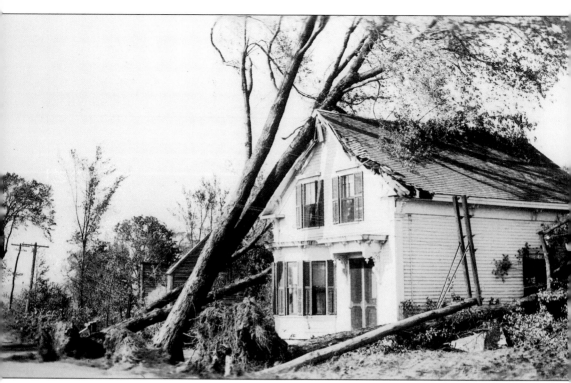

"Not a street but shows the effect of the hurricane." Above: 184 Main Street, north of Chamberlin Road. (Prescott photograph.)

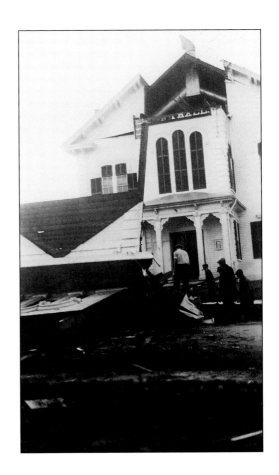

"The cupola of the Town Hall fell into the street about 6 o'clock with a terrific crash." Top photograph: Westford Town Hall, 55 Main Street. (Prescott photograph.) Bottom photograph: Westford Common looking south from the town hall. (Prescott photograph.)

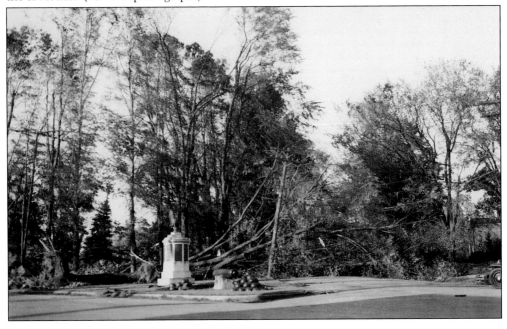

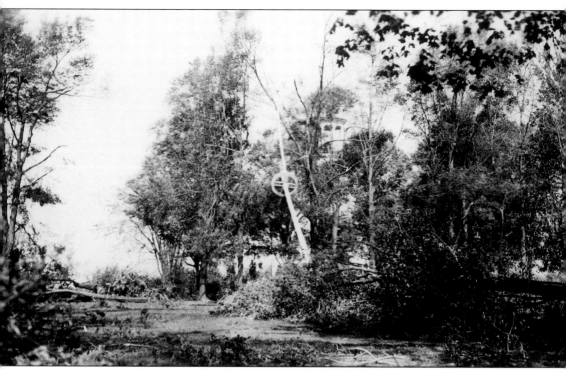

"At least a dozen big trees on the Common are uprooted, the flag pole moved from its base and resting on wires." Above: Westford Common with the First Parish Church in the background. (Prescott photograph.)

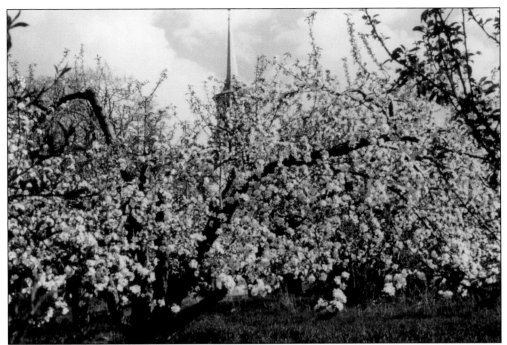

Gradually the town and the apple industry recovered. The Apple Blossom Festival continued in 1939, '40, and '41, but was discontinued during the war years. Top photograph: Apple blossom time, with the spire of the First Parish Church in view. (Seavey photograph.) Bottom photograph: World War II commemorative plaque, west of Fletcher Library, dedicated November 1947. The boulder came from Allister MacDougall's property on Blake's Hill.

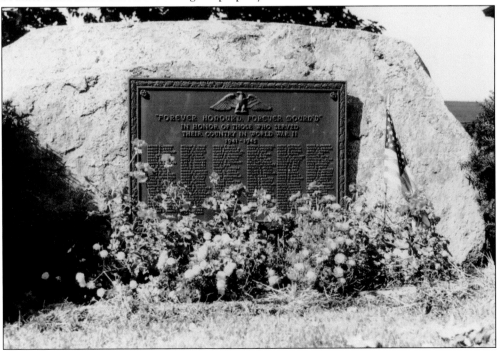

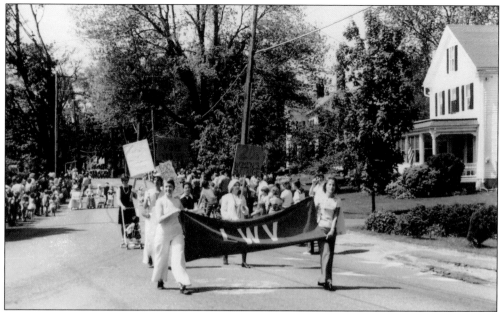

In 1968 the Apple Blossom Festival was reinstituted by the Kiwanis as an annual town event. It began with a parade led by the Westford Academy band from Westford Common to Westford Academy (which was then on Depot Street). Top photograph: League of Women Voters members Carlene Craib (left) and Elizabeth Elliot (right) carry the League banner in the 1976 Apple Blossom Parade. Bottom photograph: Ellen Harde of the Roudenbush Community Center Committee drives the float in the 1989 Apple Blossom Parade. (Westford Academy collection.)

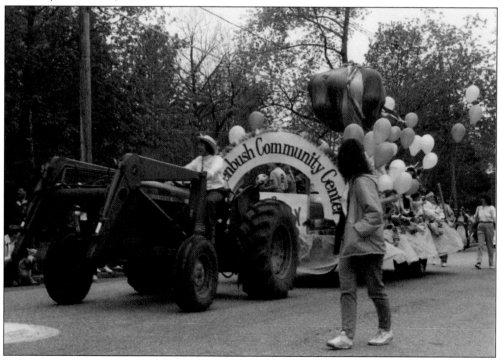

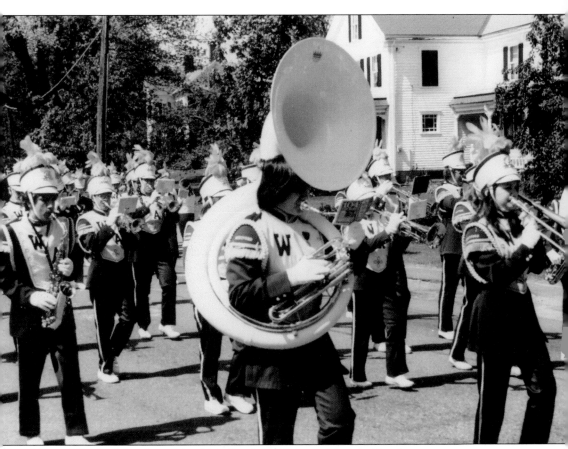

Above: Westford Academy Marching Band, 1976 Apple Blossom Parade.

In addition to the larger industries like apple growing, all sections of town had small businesses. One rarely had to leave town to do errands because all the basics were available from local merchants, and the general store had whatever no one else provided.
Top & bottom photographs: Advertisements from *The Academy Observer*, March 1, 1899. (Westford Museum collection.)

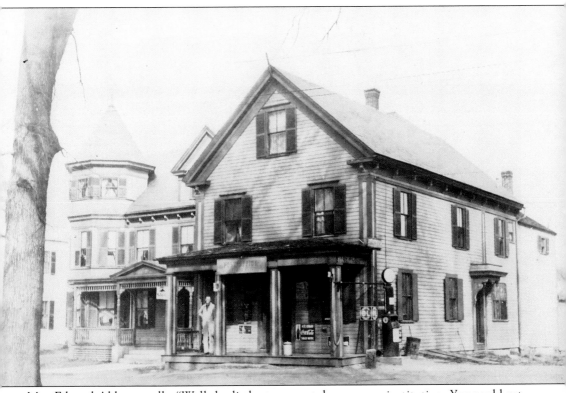

Mrs. Edward Abbot recalls: "Well the little store next door was an institution. You could get everything from ice cream cones to corsets!" Above: J.M. Fletcher's general store and post office in 1929, Lincoln Street at the Common, with Ben Prescott standing on the step. (Otis Day photograph.)

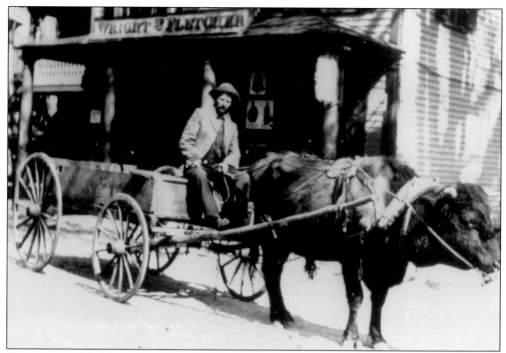

One section of town where there were not many businesses or even residents was the section known today as Nabnasset, from the Indian name Nubanussuck. There was some activity in this area during the summer, when wealthy Lowell residents came out to their cottages. Top photograph: Wright and Fletcher General Store, 40 Main Street. Delivery cart with ox. (Kennedy collection.) Bottom photograph: Nabnasset Lake, looking north from Edwards Beach.

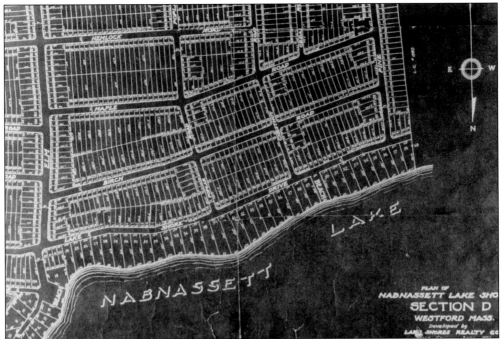

One of the town's first land developers tried to attract more summer residents to the land around Nabnasset Lake in the 1930s by dividing the land into 25-by-100-foot parcels that were available by mail order. The development fell on financial hardship and failed. But there were thriving stores year round in every other village. Top photograph: Blueprint of Nabnasset Lake Shores, April 1934. Bottom photograph: Graniteville First National, 1935, now Parent's Market. (Westford Museum collection.)

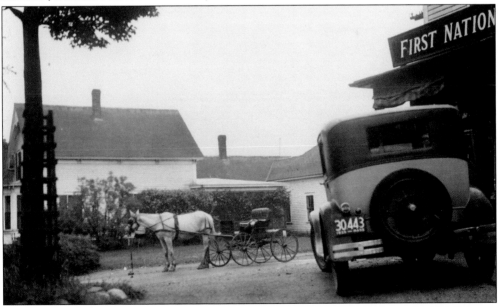

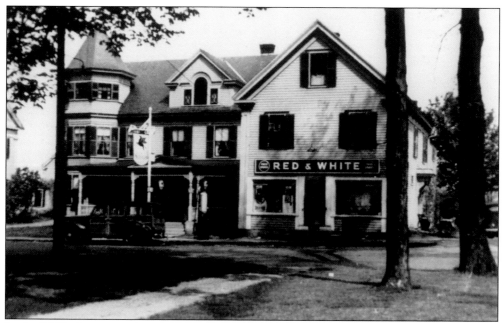

In the 1940s there were three general stores at Westford Common. Priscilla Chapin remembers "Dick Wright at the store—the Wright and Fletcher Store—Austin Fletcher was the assistant, and they had a horse and wagon, and they'd deliver." In 1969, this was the last of the three stores at the Common to close. Top photograph: Red and White Food Store, Mobil gas station, and Sunset Spa, Lincoln Street. (Kennedy collection.) Bottom photograph: Wright and Fletcher Store. (Fletcher Library collection.)

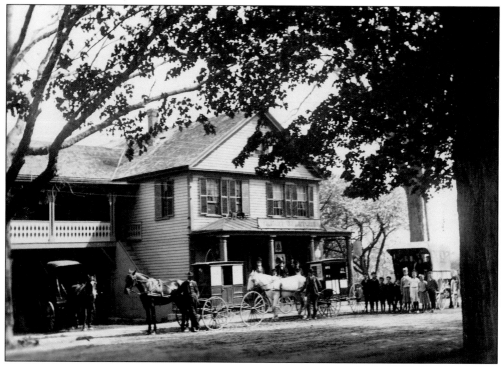

Four

Transportation

When it was necessary to leave Westford for shopping, business, or pleasure, people usually took the train. There were eight railroad stations in the town.

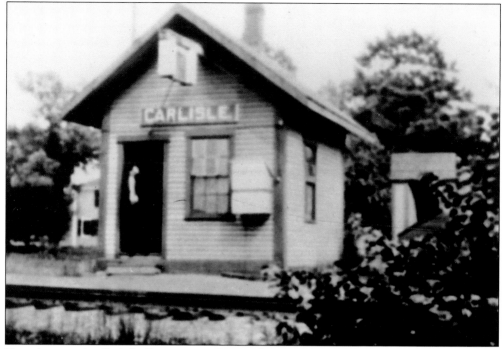

Top photograph: Carlisle Station, on the southwest corner of Carlisle and Acton Roads. (Kennedy collection.)

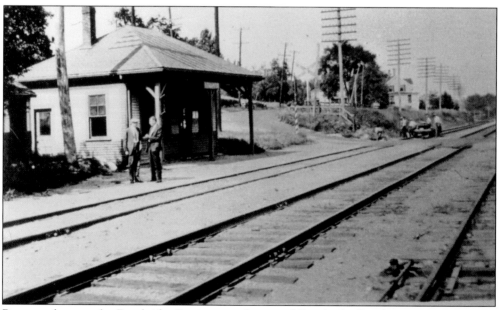

Bottom photograph: Brookside Station, northwest of Brookside Road, near Moore Road, Nabnasset. (Day photograph.)

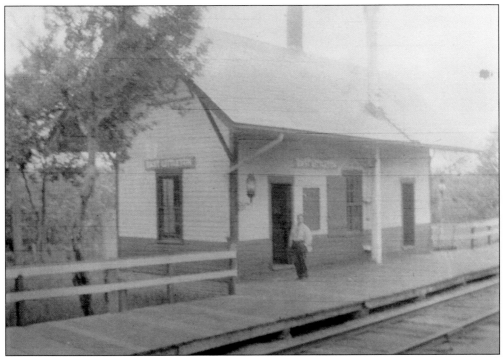

Top photograph: East Littleton Station, on Elliot Road north of Littleton Road. (Kennedy collection.)

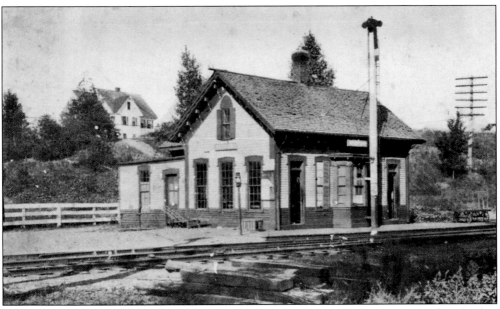

Bottom photograph: Westford Station, on Depot Street at Stony Brook, with the Fletcher farmhouse. (Fletcher Library collection.)

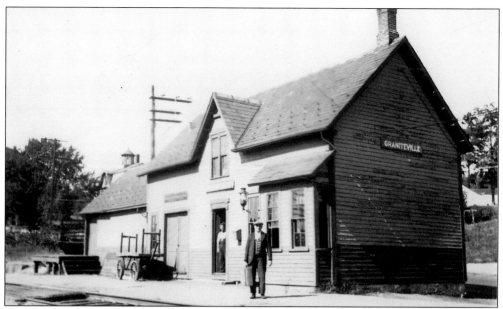

Top photograph: Graniteville Station, on North Main Street, south of Bridge Street. (Day photograph.)

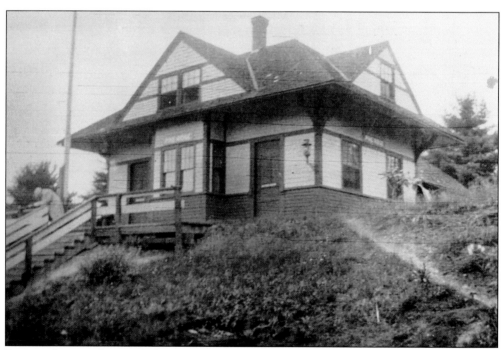

Bottom photograph: Pine Ridge Station, on Cold Spring Road near Patten Road. The building was moved to 56 Forge Village Road and is now used as a private home. (Kennedy collection.)

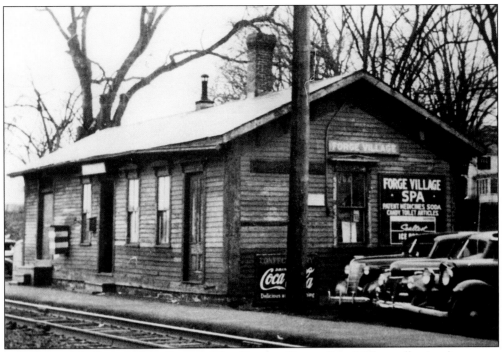

Top photograph: Forge Village Station, West Prescott Street. (MacMillan collection.)

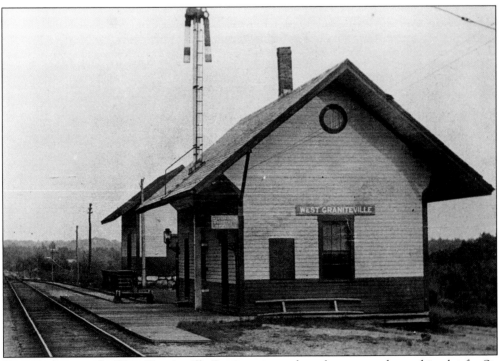

Bottom photograph: West Graniteville Station, situated on the present day parking lot for St. Catherine's Church.

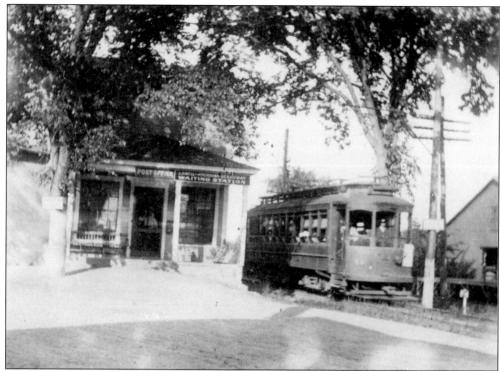

From home to station beginning in 1906, residents rode an electric trolley that ran from Ayer through Forge Village, down North Main Street to Graniteville, and on through the woods to North Chelmsford and the Lowell train. Top photograph: Lowell and Fitchburg Street railway station, now Forge Village Pizza. (Kennedy collection.) Bottom photograph: Trolley tracks along North Main Street, Graniteville. The mill pond is on the right. (Kennedy collection.)

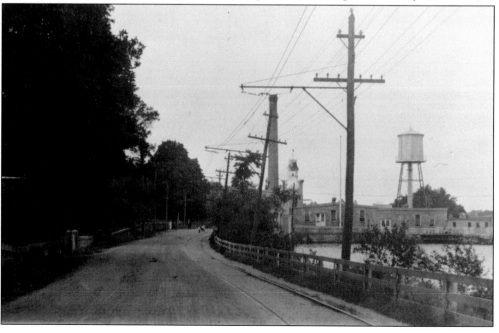

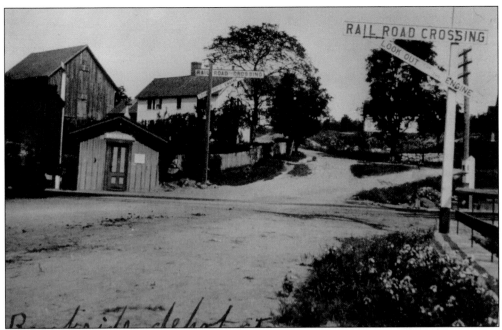

A spur track began at Brookside and ran up to Westford Center, where the trolley changed direction in front of the library. Top photograph: Brookside Depot on Brookside Road in Nabnasset. (Day photograph.) Bottom photograph: Westford trolley in front of the J.V. Fletcher Library. (Kennedy collection.)

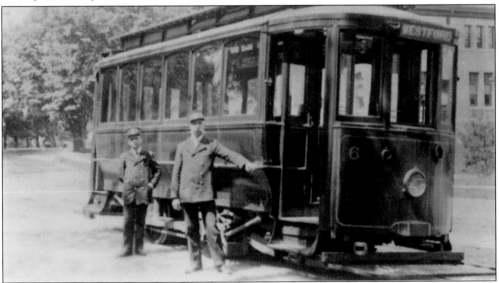

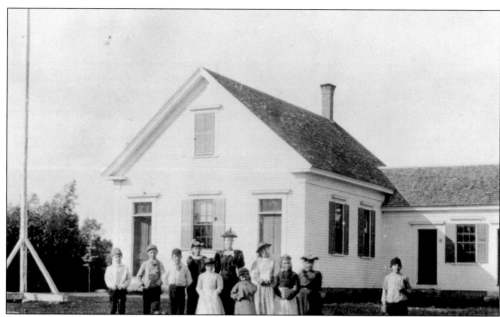

Transportation to any of the fourteen school houses was by foot. The town was divided into ten districts; one school served in the most remote districts, but there were both grammar and elementary schools in Forge Village and Westford Center. Four schools served Graniteville's District Number 10, whose population was growing rapidly. Top photograph: Minot's Corner Schoolhouse Number 6 on the south side of Route 110. Presently a private home. (Kennedy collection.) Bottom photograph: Graniteville District Number 10 School. (Kennedy collection.)

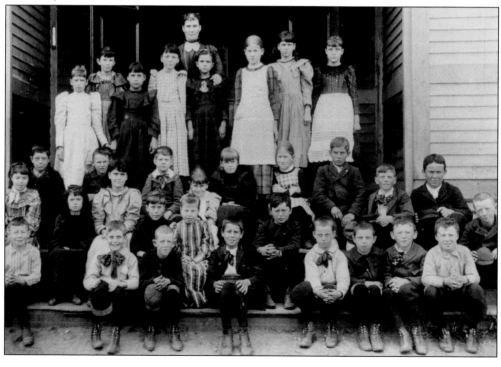

Above: Center District Number 1 School, 20 Boston Road, which served successively as the headquarters of the Spalding Light Cavalry, the Tadmuck Women's Club, and the Tadmuck Senior Center. It has been a private residence since 1995. (Day photograph.)

Top photograph: Forge Village District Number 3 School, on the corner of Pleasant and Pine Streets, now a private home. (Day photograph.)

Bottom photograph: Forge Village District Number 3 School. (Kennedy collection.)

Top photograph: The long-sought-for District Number 8 School, south of Groton Road at Gould Road, since moved to the Picking property on Gould Road. (Kennedy collection.)

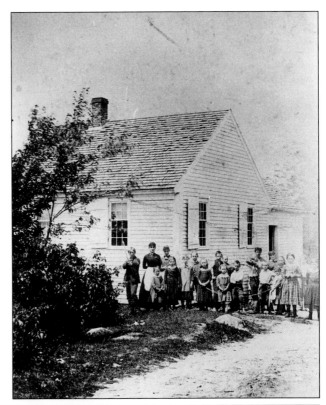

Bottom photograph: Stony Brook District Number 2 School on Stony Brook Road east of Lowell Road. (Day photograph.)

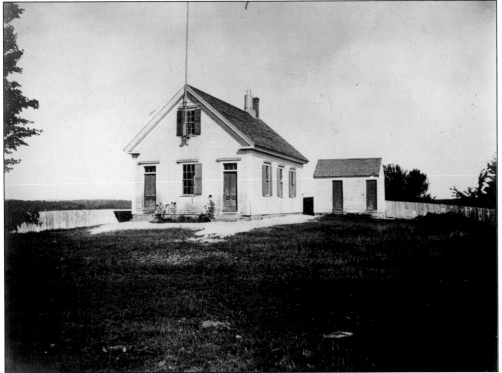

After 1905 when the smaller schools were consolidated, students could hitch a ride on the school barge, which was drawn by two horses. Top photograph: Restored school barge, Groton, Massachusetts.

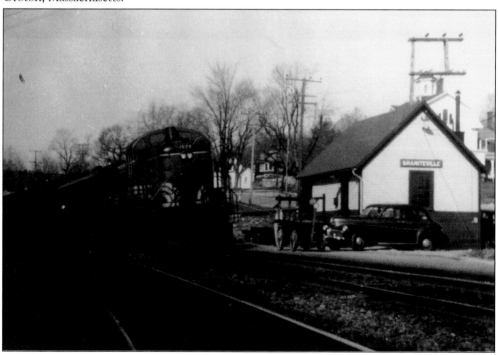

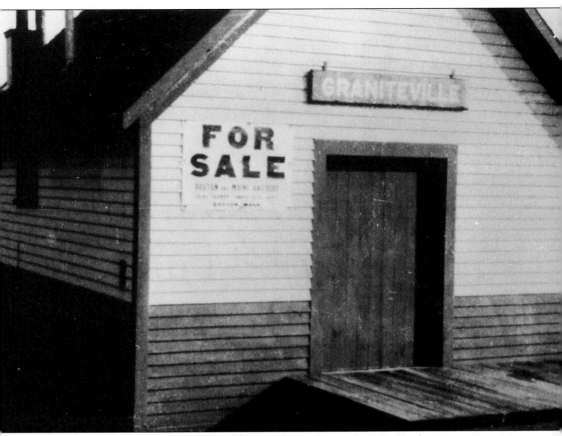

By 1921 the Westford Center trolley had stopped running, and gradually the passenger trains and remaining trolley were used less and less.

The major reason for the decline of the trolley and passenger train was the arrival of the automobile in Westford. Above: River Street Bridge, Graniteville. (Kennedy collection.)

Five

Town Government and Services

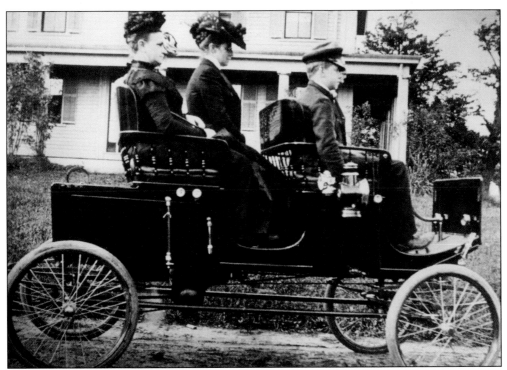

The arrival of the car brought with it some problems for the town, such as road maintenance. Recalls native resident Arnold Wilder: "Roads were extremely poor. The best road we had in town would have been what is now old Route 110, and that was a nightmare. The Burma Road they told about in World War I was nothing compared to that thing, full of potholes and one thing and another." Above: Frederick Sargent's 1902 Stanley automobile. (Kennedy collection.)

The highway department did all its work with a budget of $22,000, which covered not only the expense of road repair, but also of packing winter snows with a snow roller. Top photograph: Broadway in Graniteville. Bottom photograph: Westford Highway Department at work. Benjamin Day, highway superintendent from 1893–1904, drives the wagon. (C.E. Powers photograph.)

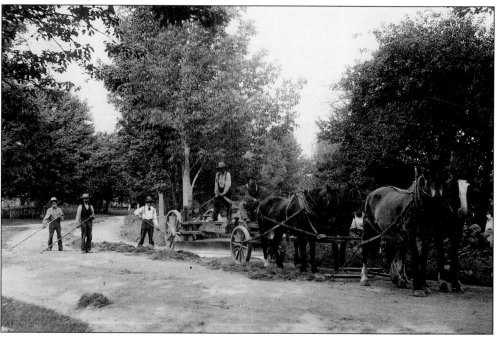

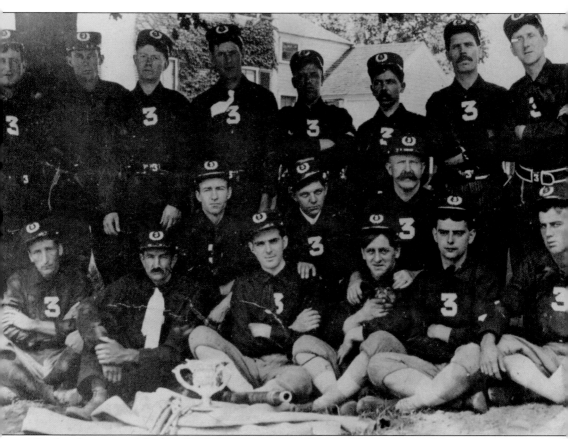

The fire department's budget for the same year—1923—was $5,400. Some of this money went to replace older equipment with new models. Above: Company #3, Forge Village.

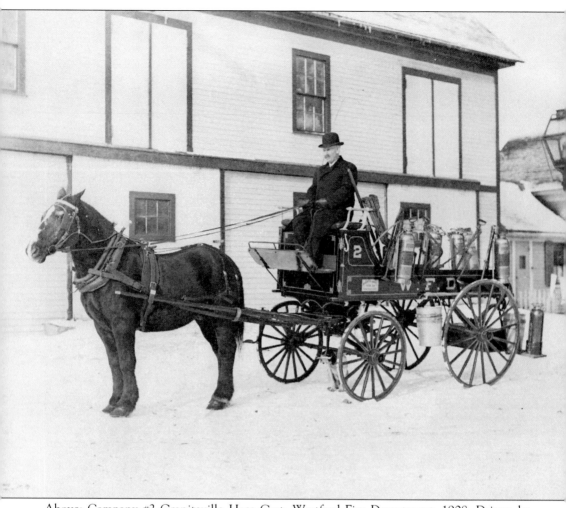

Above: Company #2 Graniteville Hose Cart, Westford Fire Department, 1908. Driven by John Healy. (Kennedy collection.)

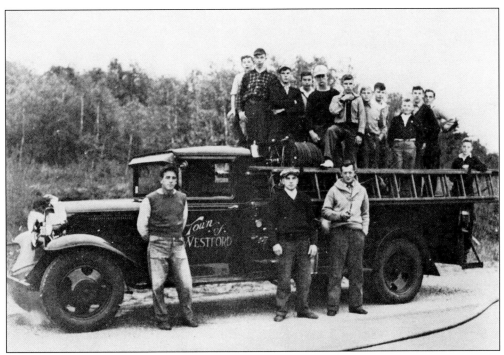

And the budget for the Town Farm, or alms house, was $5,300. That included the salaries for the caretaker and a matron. Top photograph: Volunteers in the junior fire department in Forge Village in the 1930s. Standing in front from left to right are: Joseph Lefebre, Reginald Blowey (captain), and Ed Rogers (chief). (Kennedy collection.) Bottom photograph: Town Farm, Town Farm Road, now the office of the superintendent of schools. (Day photograph.)

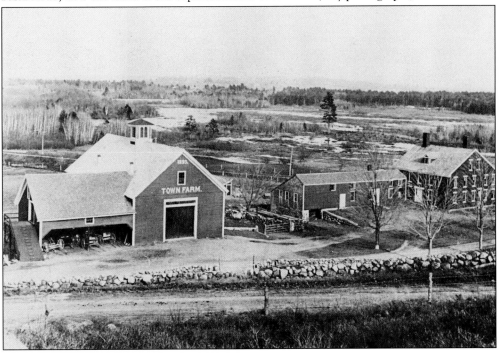

Above: An 1857 advertisement for a couple to manage the Alms House. (Kennedy collection.)

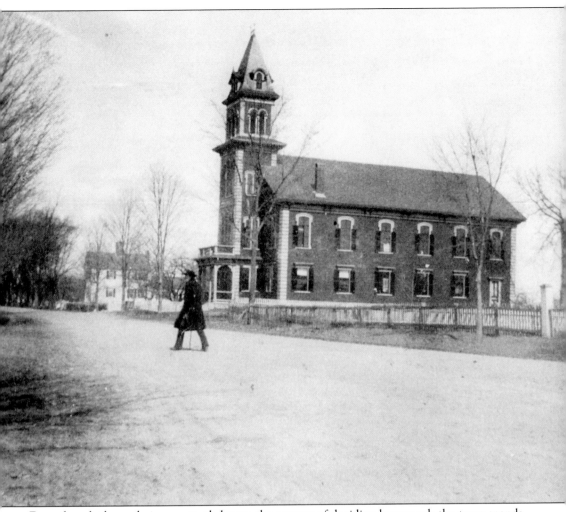

Even though the scale is now much larger, the process of deciding how much the town spends on services has changed little over the years. In 1871, the town meeting moved from the First Parish meetinghouse to the newly built town hall, where it was held until 1963. Even today, with town meetings relocated in a school gym, one can still sense the same qualities of the meeting that must have been present upstairs at the town hall. Above: The town hall prior to the 1938 hurricane. (Kennedy collection.)

Mrs. Edward Abbot remembers the town meetings: "Oh it was more fun to go to Town Meeting than to a circus! Oh they really had it out and they said what they thought too. And they'd call some fellow anything they pleased. 'Course it took an awful long time. If we wanted some electric light poles, they would have to vote each one at a time. Now that took an eternity." Top photograph: Stairway to the second floor town hall balcony prior to the 1988 renovations. Bottom photograph: View of the town hall meeting room in 1978.

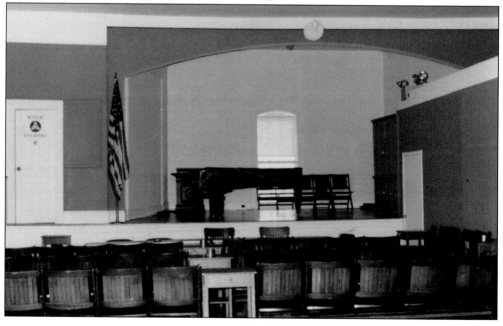

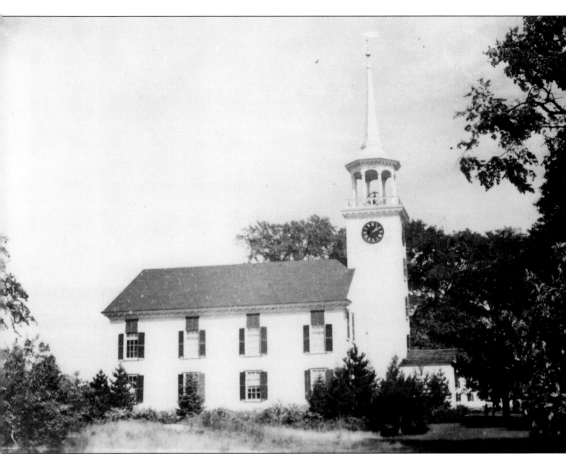

It was not totally by chance that the town meeting location remained in Westford Center. The principals in town government were not the majority who were the workers in the villages. The town fathers were the large landowners and the factory owners, who were removed from the workers by language, culture, wealth; they were even physically removed from their employees in large farmhouses and gracious homes on the hill. Above: First Parish Church. (Fletcher Library collection.)

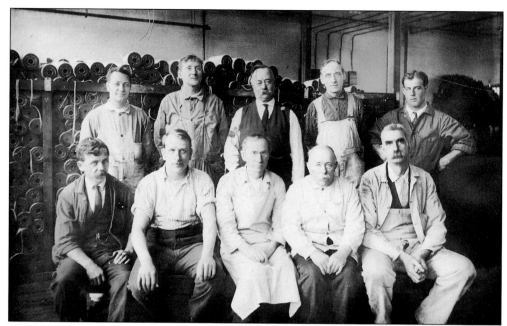

Top photograph: Mill workers at the Abbot Worsted Company in Graniteville, 1905. From left to right are: (front row) Corny Precious, Ned Hunt, Hugh Daly, Mr. Weaver, and John Kavanagh; (back row) Fred Naylor, Frank Lowther, Superintendent Collins, Jack Baker, and Fred Drolet.

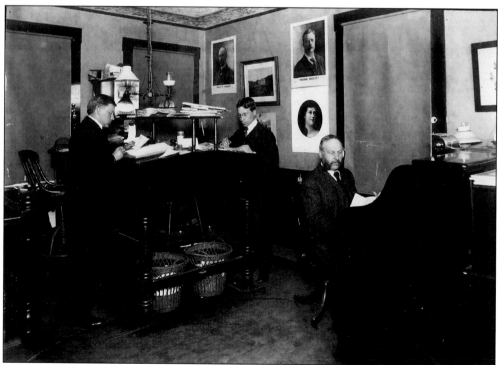

Bottom photograph: Main office of Abbot Worsted in 1905. From left to right are: Mr. Taylor, Hugh Leith, and Abiel Abbot (at desk). (Penney photograph.)

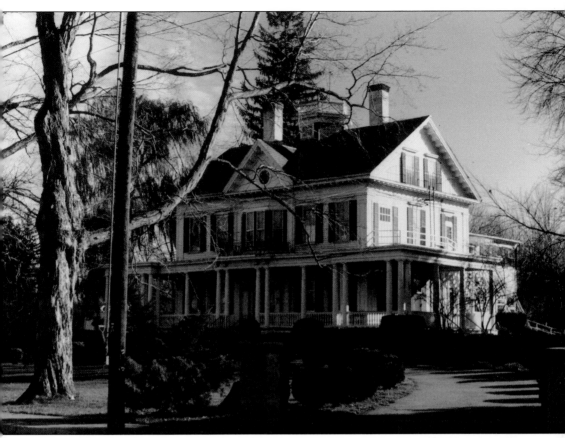

Above: Home built in 1863 by Allan Cameron, a partner in the Abbot Worsted Company. This building at 39 Main Street served as a nursing home for much of the twentieth century.

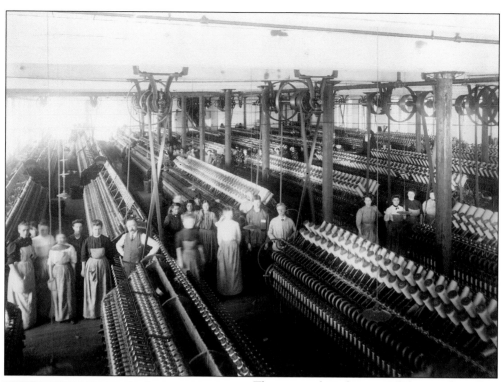

MARRIAGES

RECORDED BY THE TOWN CLERK OF WESTFORD, A. D. 1901.

DATE.	NAMES.	AGE.	RESIDENCE.	BIRTHPLACE.
April 24,	Barnard, Howard Beckwith	27	Concord.	Waterbury, Ct.
	West, Wilhelmina	25	Westford.	Carlisle.
Oct. 2,	Beebe, Willard Henry	52	Groton.	Nashua, N. H.
	York, Agnes N. (Plummer)	48	Westford	Nova Scotia.
Jan. 31,	Billson, Amos	21	Chelmsford	England.
	Clarke, Eva	21	Westford.	Lawrence.
Oct. 19,	Blowey, Samuel	30	Westford	England.
	Orange, Florence	18	Westford	England.
July 16,	Buckshorn, Louis Henry	36	Concord, N. H.	Cincinnati, O.
	Kittredge, Adeline M. (Fisher)	40	Westford.	Westford.
June 20,	Chandler, John Franklin	43	Tyngsborough.	Keokuk, Ia.
	Hildreth, Emma Augusta	41	Westford.	Westford.
July 27,	Clarke, Charles Henry	38	Boston.	Milford.
	Cass, Etta Weithea	27	Somerville.	Woodstock, N.H.
Aug. 14,	Day, Arthur Edward	23	Westford.	Westford.
	Gunter, Margaret Louisa	23	Wollaston, Ont.	Wollaston, Ont
Oct. 23,	Fletcher, John Herbert	21	Westford.	Westford.
	Gill, Mary Etta	21	Ludlow, Vt.	Ludlow, Vt.
June 5,	Fletcher, Walter Haymon	22	Groton.	Groton.
	Stirk, Ellen	21	Westford.	England.
Nov. 4,	Girard, Henry	23	Westford	Canada.
	Saroi, Mary	19	Westford.	Woonsocket, R.I.
Oct. 30,	Healy, Henry J	31	Westford.	Wells River, Vt.
	Harrington, Margaret A.	27	Westford.	Westford.
Oct. 2,	Irish, George F.	49	Westford.	Camden. Me.
	Nutting, Amy B.	32	Westford.	Lowell.
Sept. 25,	Jenkins, George Edward	36	Westford.	Whip'ngh'm,Eng
	Pedrick, Jessie Power	22	Marblehead	Marblehead.
July 9,	Leclaire, Horrist	21	Westford.	Canada.
	Paiyer, Odilide	18	Canada	Canada.
	McCarthy, Joseph F.	31	Westford.	Westford.
	Brisson, Josephine	21	Westford.	Canada.
Oct. 19,	Melvin, Charles	25	Westford.	New Brunswick.
	Prescott, Esther	23	Westford	Brownsville, Me.
Aug. 28,	Meyer, August W.	27	Boston.	Germany.
	Bennett, Elizabeth	23	Westford.	England.
Sept. 3,	Nicklin, Lorne D.	23	Hubbardston	Hebron, N. H.
	Mooring, Lizzie M.	23	Gloucester.	Wallace, N. S.
June 29,	Peterson, Lars Adolf	40	Westford.	Sweden.
	Bloberg, Augusta	33	Westford.	Sweden.
Feb. 24,	Shea, Joseph F.	22	Westford.	Lowell.
	Kimball, Inez F.	16	Westford.	Chelmsford.
June 8,	Stiles, Lorne C.	22	Westford.	New Brunswick.
	Mann, Carrie F.	23	Westford.	Providence, R. I.
Aug. 10,	Wyman, Walter W.	52	Westford.	Tyngsborough.
	Ditmars, Gertrude A	39	Annapolis, N. S.	Annapolis. N. S.

One omitted.

Number of marriages recorded	24	American groom and foreign bride.	6
Solemnized in Westford	6	American bride and foreign groom.	5
Westford grooms	15	Second marriage of groom	4
Westford brides	17	Second marriage of bride	2
Between Americans	8	Third marriage of groom	1
Between foreigners	5	Solemnized by Westford clergymen	5

GILMAN J. WRIGHT, *Town Clerk.*

There was a line drawn, and the people in the villages developed a cautious attitude about the people in the Center. The workers were dependent on them for jobs, but felt looked upon as second-class citizens. And their feelings were somewhat justified. After all, for two years the town report did distinguish between "natives" and "foreigners" in marriage records. Over the next twelve years the categories were changed to "Americans" and "foreigners," and the practice was dropped altogether in 1903. Top photograph: Number 1 Abbot spinning mill, 1905. (Penney photograph.) Bottom photograph: Town clerk's record of marriages, 1902 Town Report.

Six

The Second Immigration

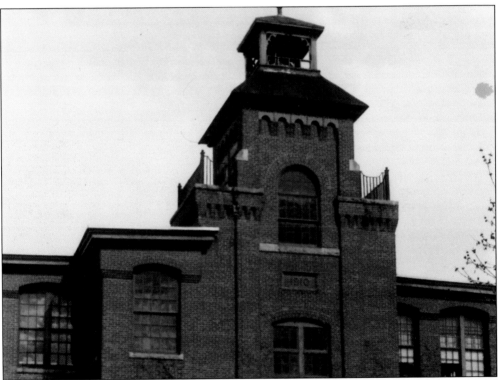

Through World War II and into the 1950s the town changed little. Abbot Worsted continued to be the major employer and the population remained fairly stable. Then in 1956, 101 years after it began in Graniteville, the Abbot Worsted Company closed down. Says employee Jacob Tereshko: "I work all my life with the Abbot. I start work in 1913, I work up to here, up to 1956 when close-ed." Above: The Abbot Worsted Company occupied this building on Pleasant Street in Forge Village from 1879 to 1956. Murray Printing Company, then Courier Corporation, used this building from 1958 until 1993. As of early 1996, the building stands empty.

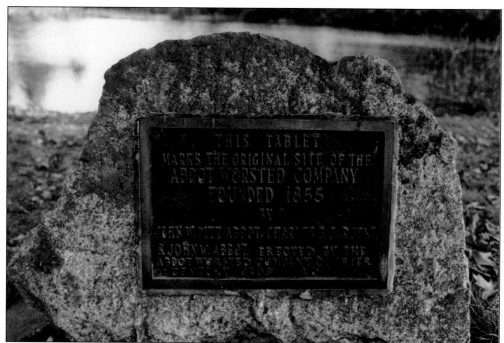

And at the same time, a second immigration began into Westford that changed the town as much as the immigration of the mill workers had fifty years before. As the electronics industry blossomed along Routes 128 and 3, Westford became an ideal place for commuters to settle. The opening of an exit off Route 495 for Westford in 1961 made the town even more accessible. Top photograph: Plaque marking the site of the original Abbot Worsted building between the mill pond and North Main Street, just north of Bridge Street in Graniteville. Bottom photograph: Looking south to Fletcher and Heywood Roads from 10 Cold Spring Road.

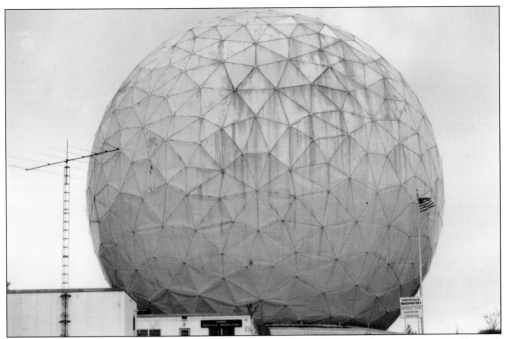

Top photograph: MIT's Haystack Observatory, built in 1964, is located on Millstone Hill Road, off Groton Road.

Bottom photograph: Route 495 south, approaching Exit 32 in Westford.

Cottages in Nabnasset that had been summer homes were winterized for year-round living, and the development plan around Nabnasset Lake that had gone defunct in the 1930s now became a reality. Top photograph: Cottages on Nabnasset Lake looking east from Lake Shore Drive North. Bottom photograph: 48 and 50 Newport Drive.

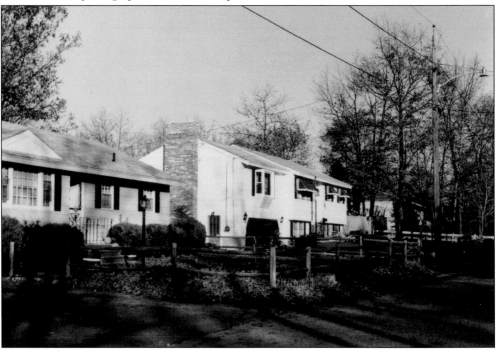

The town's purchase of Abbot's water company in 1956 meant the extension of water mains out of the villages, and the development of acres of open land. Top photograph: Field west of Concord Road (Route 225) between Route 110 and Powers Road. Bottom photograph: 87 Carlisle Road at the corner of Texas Road in the fall of 1978.

The population grew as much in the decade between 1950 and 1960 as it had in the sixty years from 1890 to 1950. And the new immigrants were a more mobile society, attracted here by homes and highways and charmed by the town itself. Many, however, were subsequently transferred by the national companies for which they worked. Says former postmaster Leo Connell: "After these few years I've been out of the post office, a lot of people I don't know. I'm a stranger when I go to the post office now." Top photograph: 13 Tallard Road nearing completion, fall 1978. Bottom photograph: Moving van at 88 Forge Village Road.

Seven

Her Past Gives a Continuity to Her Present

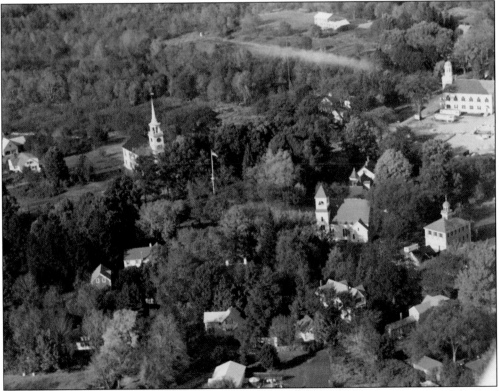

Above: Aerial view of Westford Common from the south, during the construction of the fire/
police station in 1973. (Seavey photograph, Fletcher Library collection.)

Westford will of course continue to change, but her past gives a continuity to her present. Top photograph: Quilt made by members of the First Parish Church for the church's 250th anniversary in 1975. Bottom photograph: Sign made by students at Nashoba Valley Technical High School for Westford's 250th anniversary.

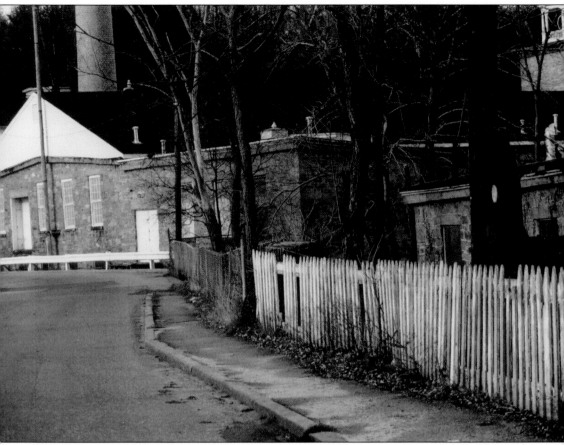

Abbot Worsted is gone from Graniteville, but the mill buildings remain, occupied by new businesses. Above: Broadway in Graniteville, looking toward North Main Street.

The arch bridge—built in 1873 to carry trains from Nashua, New Hampshire, to Concord, Massachusetts—is today in the middle of a town conservation area where we can walk and marvel at the bridge's construction. Top photograph: The arch bridge over Stony Brook on the old Red Line, between Milot Road and Forge Village Road, near the Russell Bird Sanctuary. From left to right are: Adam Morton, Marilyn Day, and Mary and Jennifer Morton. Bottom photograph: A view of the Old Arch Bridge in 1925. (Seavey photograph.)

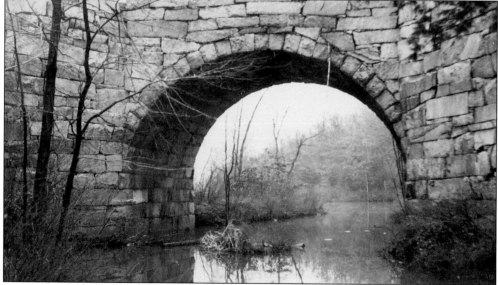

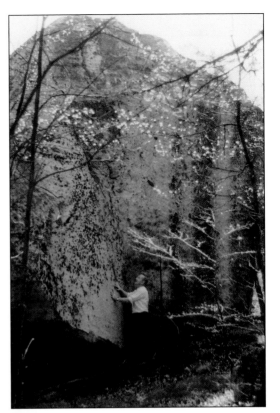

In the north of town, glacial boulders named "The House and Barn" continue to be climbed by Westford children as they have been for generations. Right: Allister MacDougall at the Barn Rock west of Wyman's Beach.

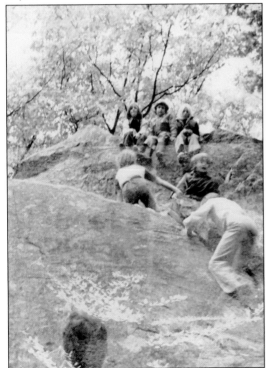

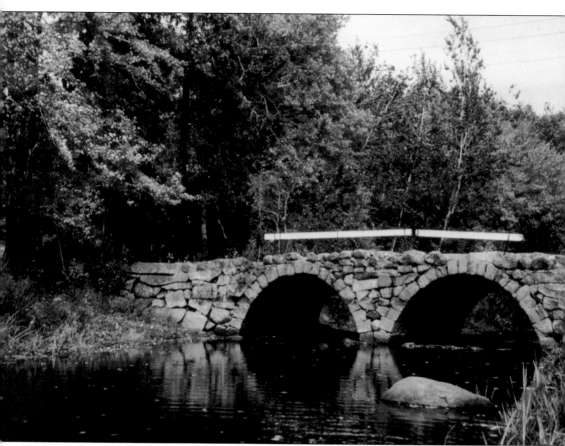

The 150-year-old double arch bridge still carries daily traffic over Stony Brook. The remaining quarry continues to provide curbing, paving stones, and steps, including those used in the Quincy Market restoration begun in 1975. Above: Double arch bridge where Stony Brook Road crosses over Stony Brook. (Edna MacDougall photograph.)

Top photograph: H.E. Fletcher and Company granite quarry, Groton Road.

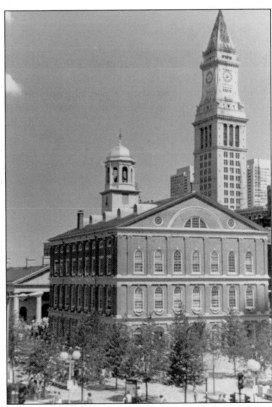

Bottom photograph: Faneuil Hall, Boston. (Dexter photograph.)

Westford's last remaining dairy farm closed in 1988, but third-generation members of the Fletcher family still run a farm stand on the land. Top photograph: Stony Brook Acres was located on Plain Road north of Stony Brook. Bottom photograph: Fletcher farm stand, 1996.

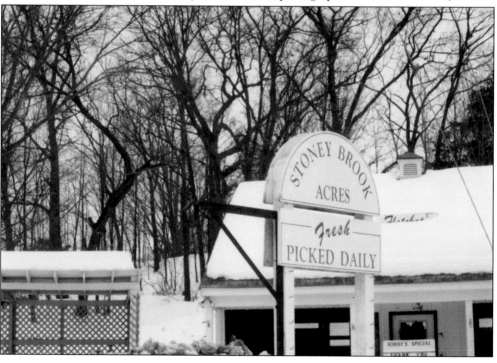

Eight

People and Their Accomplishments

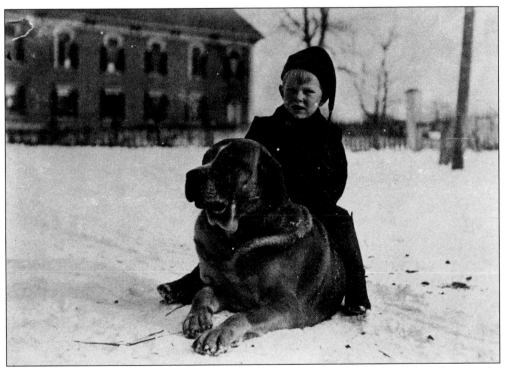

Looking at Westford's past and present, her most unique strength has always been her people, in their talents, in their labors, and even in their differences. Many of the people who have been an important part of Westford in this century are still living here, still contributing to the community. Their contributions have resulted in impressive accomplishments in the town, building on the accomplishments of those who lived here before them. Above: Allister MacDougall on Hector, J.W. Abbot's dog, sitting in the middle of Lincoln Street, c. 1905. (Fletcher Library collection.)

Top photograph: Westford Fair Committee. From left to right are: (front row) Mrs. William Parfitt, Mrs. George (Helen) Wilson, Miss Stone, and Mrs. Don Judd; (back row) Jennie Hartford, May Day, and Mrs. Kenneth Wright. (Fletcher Library collection.)

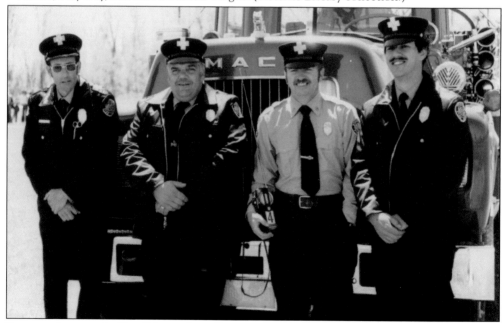

Bottom photograph: Fire fighters from Company #4, Nabnasset, at the 1977 Apple Blossom Parade. From left to right are: Ted MacLeod, Lionel "Butch" Boisvert, Tom Pehrson, and Bert Fellows.

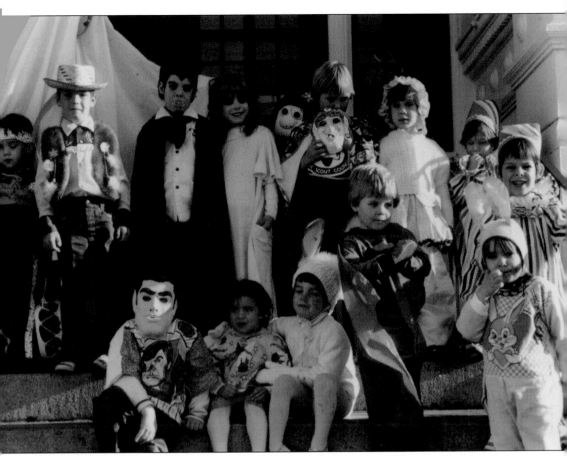

Above: Halloween parade at the Roudenbush Community Center, 1977.

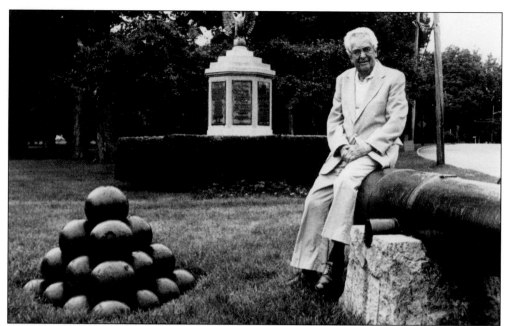

Top photograph: Gordon Seavey, born in Westford on October 25, 1905. (Courtesy of the *Lowell Sun*.)

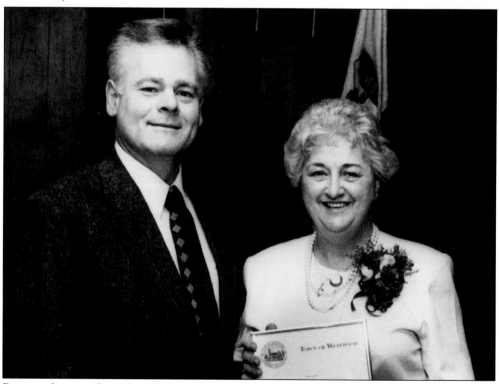

Bottom photograph: Helena "Mickey" Crocker, born in Forge Village on October 20, 1928, is honored by Bob Herrmann, chairman of the selectmen, on Mickey's retirement in 1992 as town aide. (Courtesy of the *Westford Eagle*.)

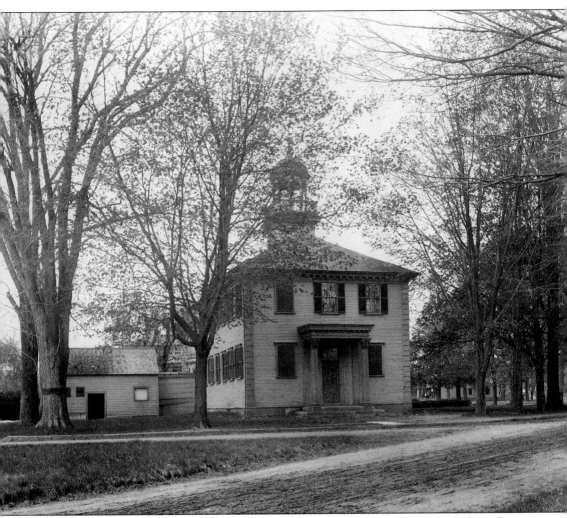

One example of the accomplishments of Westford's people is the founding of Westford Academy by a group of residents in 1792 as one of the first private academies in the state. The 1794 building served as a school for over one hundred years in one location, then was moved by oxen down Boston Road where it served as a fire station for another fifty-five years. In 1976 the original building was renovated and became the town museum; the volunteer labor for this project was provided by residents and Nashoba Valley Technical High School students. Above: The first Westford Academy building stood southwest of Boston Road at Hildreth Street from 1794 to 1910. The original granite step has marked the site since 1942.

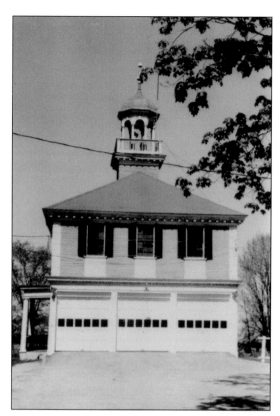

Top photograph: After the original Westford Academy building was moved to 2 Boston Road, it was used as the Center fire station from 1917 to 1974.

Bottom photograph: Westford Museum, dedicated in 1976.

110

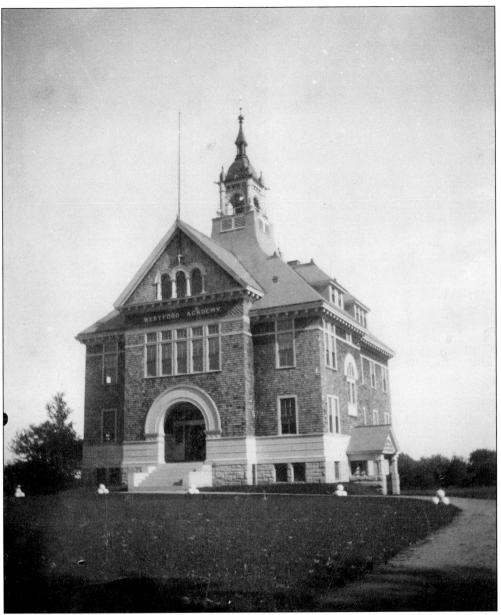

In 1895 a new state statute required towns with a population over five hundred to provide public school education through grade twelve. Westford's public schools went only to the eighth grade. So again, the people of the community worked together. The second Westford Academy was built in 1897 to serve as a private school and also to provide instruction for all Westford scholars of secondary school age whose tuition was paid to the Westford Academy trustees by the town. It was not until 1928 that the town purchased the building for $3,000. It was used as a public high school until 1955. Above: The second Westford Academy in 1898. (Julia H. Fletcher photograph, Westford Museum collection.)

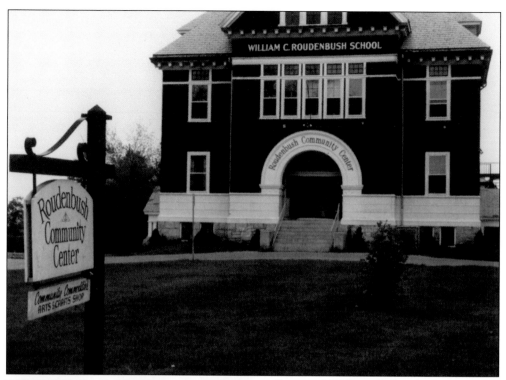

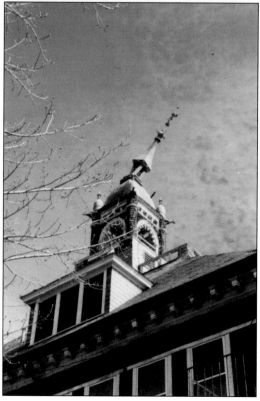

Renamed William C. Roudenbush
School in 1957 in honor of William
Roudenbush, who served as Westford
Academy principal from 1912 to 1937,
the school served younger grades until it
closed in 1973. In the fall of 1973, the
building opened as the Westford branch
of the Lowell YWCA. In 1975 it became
the Roudenbush Community Center. Top
photograph: Roudenbush Community
Center, 65 Main Street. Bottom
photograph: The Roudenbush spire leans
at a precarious angle.

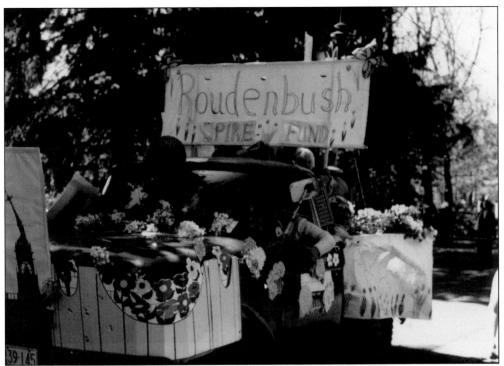

Even the winds of a spring storm that tipped the Roudenbush spire on Palm Sunday in 1977 did not dampen Westford's community spirit. A town-wide fund drive, including a float in the Apple Blossom Parade, enabled the restoration of the spire on the building by October. Top photograph: "Truckie," driven by Ellen Harde, carries the damaged Roudenbush spire in the May 1977 Apple Blossom Parade to raise funds for the spire's repair. Bottom photograph: The weathervane is installed atop the repaired spire in October 1977.

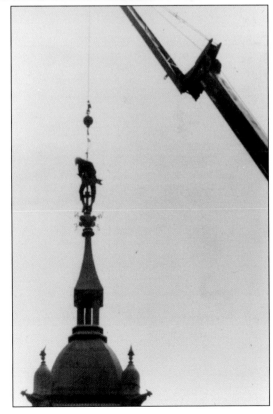

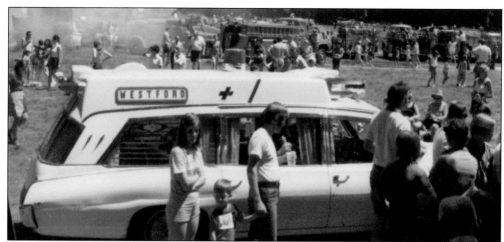

The need for an ambulance in town was met by the 4H Club, who headed a fund drive in the 1960s to purchase one for the fire department. Today, the Ambulance Fund continues to purchase a new ambulance as needed entirely from residents' gifts. In the 1970s, Boy Scouts worked to build the picnic area overlooking Grassy Pond where the Junior Women's Club installed the Life Course. Jaycees and Rotary members worked to maintain the trails. Top photograph: Pontiac ambulance on display at the 1971 Firemen's Muster. Bottom photograph: Grassy Pond, Plain Road.

The Jaycees created the town beach on Forge Pond, truck load of sand by truck load of sand. Each year working on projects such as these bring the people of Westford closer together. We also pray together. Top photograph: Town beach, Forge Pond. Bottom photograph: Graniteville Methodist Church and the mill pond from North Main Street in 1976.

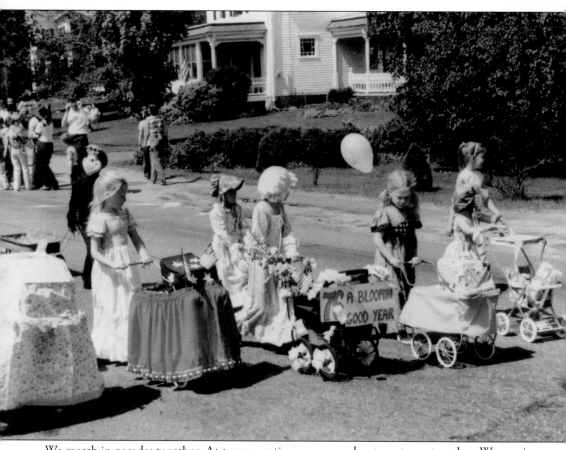

We march in parades together. At town meeting we worry about our taxes together. We survive blizzards together. Above: The 1976 Apple Blossom Parade passes in front of 70 Main Street.

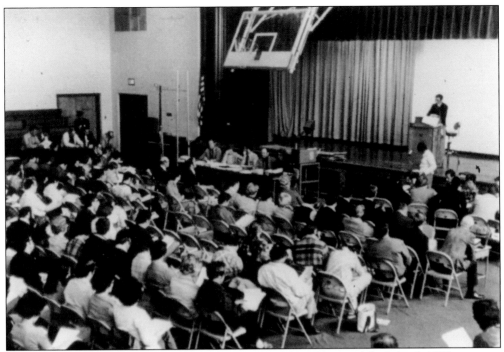

Top photograph: Town meeting in the gymnasium of the Abbot Middle School, 1979.

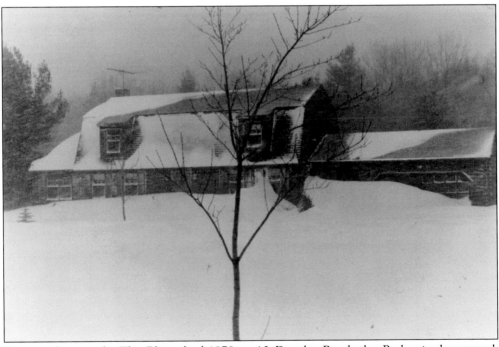

Bottom photograph: The Blizzard of 1978 at 10 Douglas Road, the Berkowitz homestead. (Marlene Bryant photograph.)

Different routes have brought each of us here, but an understanding of the unique history that we share by living in Westford cannot but make each of us feel a greater sense of pride in our common heritage and lead to us a greater sense of community. Top photograph: Boston Road looking toward the Common. At the right is 14 Boston Road. (Westford Museum collection.) Bottom photograph: Beth Shaw with daughters Jordana and Rebecca at the 1977 Strawberry Festival at the First Parish Church, buying a reprint of Hodgman's *History of Westford*.

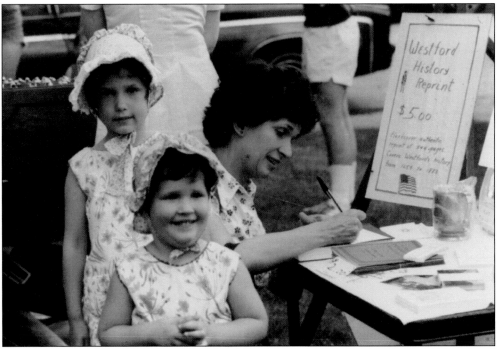

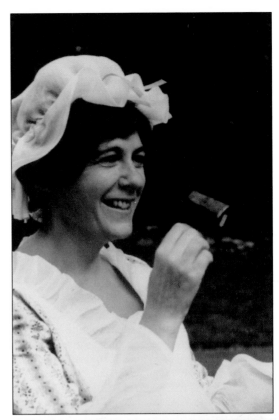

Right: Westford historian June Kennedy quaffs from Colonel John Robinson's rum ration cup. Colonel Robinson led Westford Minutemen to the Battle of Concord on April 19, 1775. Bottom photograph: School picture, c. 1917.

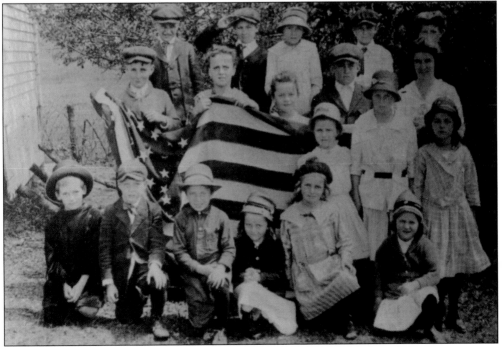

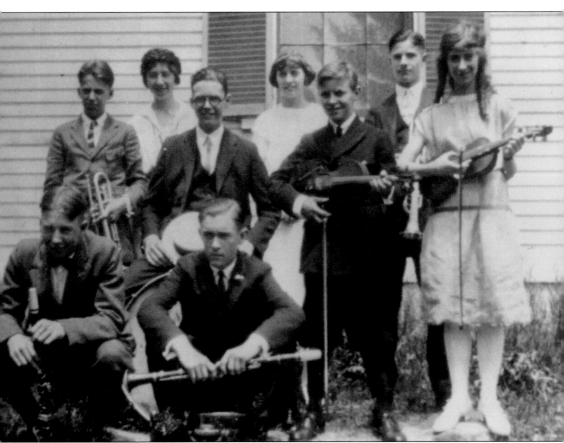

Priscilla Chapin muses: "Well, it's just not the same place anymore. It's a big community. It was a little village before, you see. I liked it the way it was. But I also find it very fascinating the way it is now." Above: Westford Academy orchestra in 1929.

Historical research
and oral history interviews
conducted by the following members
of the League of Women Voters:

Lillian Cooper, Nancy Kendall,
Meryl Schwartz, Esther Eddy, Judy Kusmin,
Sue Smith, Claire Gillen, Pat Matheson,
Leslie Thomas, Sharon Hellstedt,
Nancy Russo, and Mary Trout.

Historical interviews conducted in 1977–78
with the following residents:

Mrs. Edward Abbot (1898–1983)
Alex Belida (1918–)
Emily (McKniff) Blott (1894–1987)
Mrs. Lowell Chapin (1898–1991)
Leo Connell (1899–1992)
George Downey (1924–)
Jacob Tereshko (1885–1987)
Arnold Wilder (1908–)
Peter Worobey (1891–1991)

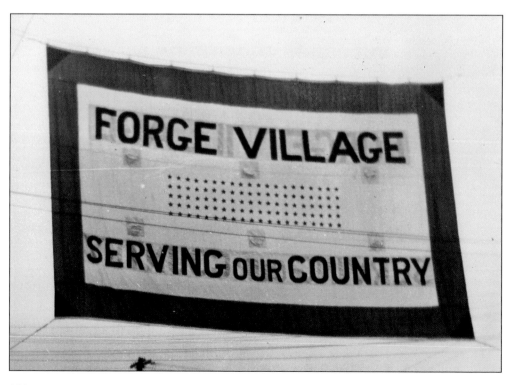

WESTFORD
200TH ANNIVERSARY
SATURDAY, SEPT. 21

9.30 a. m. Ball game and other sports.

11.30 to 12.30 Reception to guests.

12.30 p. m. Dinner at Town Hall.

3.00 p. m. Historical pageant on Prospect Hill. Special music for pageant by Abbot Worsted Co. Band.

SUNDAY, SEPT. 22

11.00 a. m. Church services at Unitarian Church. Church services at St. Catherine's church.

2.00 to 4.30 Band Concert at common, Abbot Worsted Co. Band

3.00 p. m. Planting of 200th Anniversary Tree.

MONDAY, SEPT. 23

.00 p. m. Fireworks, Whitney Playground.

.30 to 9.30 p. m. Concert in Town Hall.

.30 p. m. Anniversary Ball

Above: Newspaper advertisement for the town's 200th celebration in 1929.

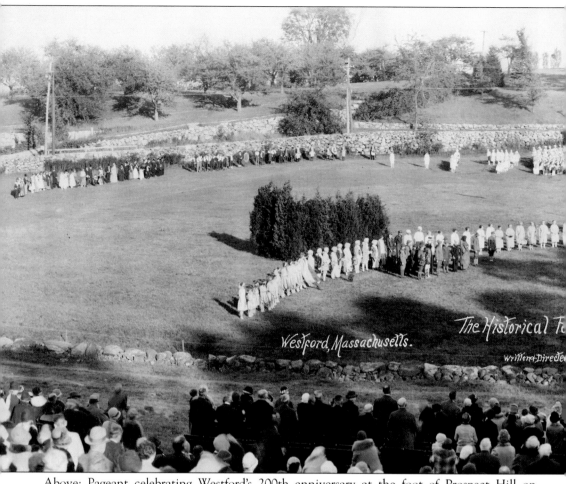

Westford, Massachusetts.

The Historical Pa

Written-Directe

Above: Pageant celebrating Westford's 200th anniversary at the foot of Prospect Hill on

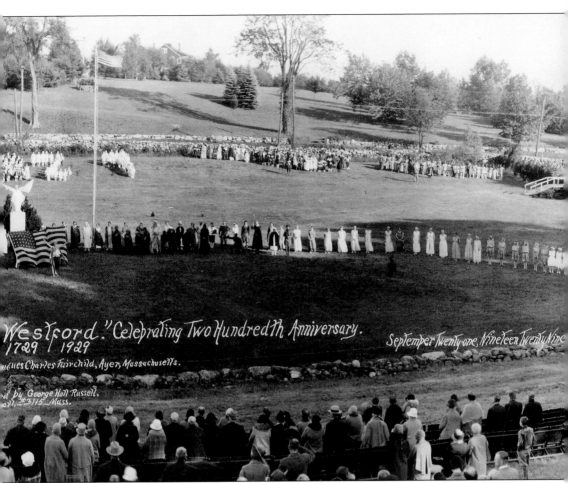

Westford." Celebrating Two Hundredth Anniversary.
1729 | 1929
September Twenty-one, Nineteen Twenty Nine
...ues Charles Fairchild, Ayer, Massachusetts.
...d by George Hall Russell,
...pt. #3115, Mass.

Hildreth Street, one-eighth mile from Westford Common.

Old photographs donated from the collections of the following:

Quincy Warren Day (1867–1933)
Walter Otis Day (1891–1993)
Richard Hall (1911–1981)
June Kennedy(1935–)
Edna MacDougall (1892–1987)
Bill MacMillan (1921–)
Thomas McKniff (1901–1982)
Gordon Seavey (1905–)
J.V. Fletcher Library
Westford Museum

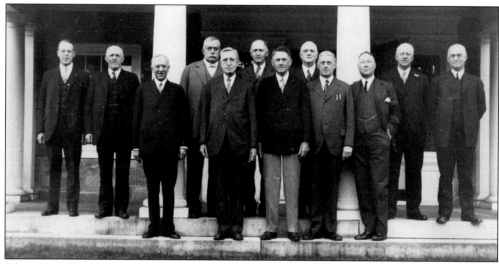

Above: Westford Academy Trustees, May 25, 1931. From left to right are: Charles L. Hildreth, Herbert V. Hildreth, Julian Cameron, Oscar Spalding, the Hon. Frederic Fisher, Dr. A. Warren Stearns, the Hon. Herbert E. Fletcher, John C. Abbot, Charles E. Bartlett, Edward Abbot, William Taylor, and Edward Carney. Westford Academy became a public school in the 1920s, but because the school committee agreed to retain the name, Westford Academy trustees continue to manage an endowment. Each year the trustees give many college scholarships to graduating seniors. (Photographed at the home of the Hon. Herbert E. Fletcher by Charles L. Hildreth, Westford Museum collection.)

Westford Academy

Standing of the Pupils
For the term ending Nov. 25th, 1862
On a scale of 10.

Name.	Average	Rank	No. of studies	Absences ½ days	Tardinesses	Deportment.
Emory A. Wright	9.75	1	3	5a		10
Mary A. Beane	9.70	2	3	25a		10
Matilda A. Proctor	9.68	3	3	11a		10
Sarah A. Day	9.64	4	3	6		10
Ellen M. Sargent	9.62	5	2	12		10
Marion L. Wright	9.60	6	4	5	2	10
Emily F. Fletcher	9.43	7	3			10
Eliza J. Burbeck	9.40	8	3		2	10
Timothy Sullivan	9.39	9	3	2		8.83
William L. Kittredge	9.37	10	3	20	1	9.69
Goodrich A. Dow	9.35	11	4	2		9.73
Abiel J. Abbot	9.34	12	3	4		9.91

Above: "Westford Academy. Standing of the Pupils for the term ending November 25, 1862. On a scale of 10." Notice the number of female students. On August 3, 1792, the Proprietors of Westford Academy voted to adopt rules and laws including: "II. That said school shall be free to any nation, age, or sex provided always that no person shall be admitted a member of said school unless such person can at least read in the Bible readily without spelling." The tuition was voted: "IV. . . . the sum of nine shillings per term." (Westford Museum collection.)

Recent photographs
provided by:

Marlene Bryant, Rick Kendall,
Jim Lacey, *Lowell Sun*,
Richard Schwartz, Beth Shaw,
Bob Shaw, *Westford Eagle*,
Students in the Westford Academy
Oral History Project, 1989